MANCHESTER

THE POSTCARD COLLECTION

ERIC KRIEGER

AMBERLEY

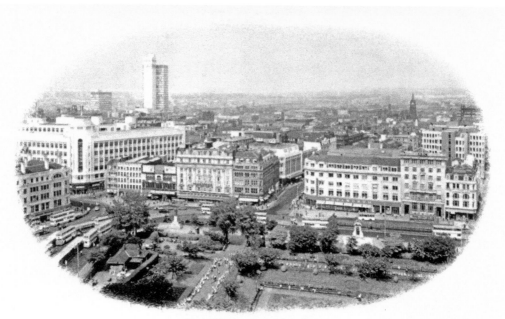

Piccadilly Gardens, Manchester

First published 2017

Amberley Publishing
The Hill, Stroud, Gloucestershire, GL5 4EP
www.amberley-books.com

Copyright © Eric Krieger, 2017

The right of Eric Krieger to be identified as the
Author of this work has been asserted in accordance with
the Copyrights, Designs and Patents Act 1988.

ISBN 978 1 4456 7280 9 (print)
ISBN 978 1 4456 7281 6 (ebook)

British Library Cataloguing in Publication Data.
A catalogue record for this book is available from the
British Library.

Origination by Amberley Publishing.
Printed in Great Britain.

CONTENTS

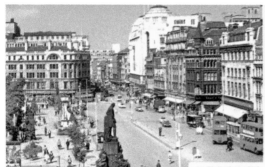

MANCHESTER

MANCHESTER—AS USUAL

INTRODUCTION

On 1 October 1870, the British postal authorities introduced an official plain postcard that could be sent through the mail for half a pre-decimal penny – less than the rate for a letter. At first, the cards had to be bought from post offices, and the 'stamp' was already printed on the card. Two years later, privately produced cards were permitted, but these had to be sent to the Inland Revenue Department to have the stamp either printed or impressed. There were rules about the size of the cards, and the fact that the recipient's name and address must appear on one side by itself, so it was easier to read. Any message or graphic had to be on the other side. Innocent though this innovation might seem, there soon appeared comments in the press about the open nature of these postcards. Offensive messages, it was claimed, might be written for all to read – such as post workers or servants. Traders saw theses uncovered cards as a means to recover real and fictitious debts, by threatening to expose non-payers. The Bishop of Gloucester said that he would shield his comments from uneducated eyes by composing his messages in Latin.

There was nothing to stop sketches and images appearing on the non-address side, but in 1894 private cards could be mailed by affixing an adhesive stamp. This was a relaxing of the rules that aided the development of the pictorial postcard, which reached a golden age in the Edwardian period. After lobbying from the printing trade, and by a Canterbury MP, Henniker Heaton, for larger cards already in use in certain European countries, the Post Office, in 1899, allowed cards of size 5.5 inches x 3.5 inches. Heaton had blamed the smaller cards for cramped handwriting, and for denying stationers in the UK the chance to 'adorn their cards with engravings, photographs and chromos'. Then, in 1902, it was clarified that the address and message were able to share the same side of the card. This meant that the image could be printed in full on the other side.

So, by the new century, the country was ready for the Edwardian postcard mania. There were cards of all subjects, but one of the favourite themes was that of the topographical view, showing street scenes, buildings and parks. Manchester, by 1900, was one of the United Kingdom's, and the world's, major cities, the centre of a huge industrial region. Over the previous century it had become a municipal borough and had grown in administrative area by absorbing neighbouring townships. Still the centre of the cotton trade – although by then more a place of exchange and warehouses than mills – there was also significant engineering output. Railway locomotives and motor cars were built here (Rolls and Royce met in the Midland Hotel). The railways had arrived in 1830, with the pioneering Liverpool & Manchester line. Since then, London Road, Victoria, Exchange and Central stations had been opened and connected Manchester to other urban centres. The trams, horse-drawn and privately owned since 1877, had been taken over by the Corporation and converted to electric traction. The main streets were thronged with people and traffic. The Manchester Ship Canal, which opened in 1894, was one of the engineering wonders of the Victorian age. The university had emerged from Owens College, and in the years before the First World War was a leading research centre in fundamental physics. Postcard publishers found buildings worthy of record: Manchester

Cathedral, the Royal Exchange, Town Hall, Central Library, Art Gallery, Assize Courts and Royal Infirmary. They produced cards of theatres, football clubs and pleasure parks. Postcards were used to promote and advertise shops, stores and textile manufacturers.

Publishers of Manchester postcards ranged in size of operation from nationwide companies working on an almost industrial scale, down to local photographers producing each card by hand. In the former category were Raphael Tuck & Sons of London, and Valentine & Sons from Dundee. The latter were probably the biggest producers of view cards in the country, and a local trade directory of 1911 reveals that they had business premises on Fountain Street. At an intermediate level was James L. Brown, who worked from a building on Stockport Road, near Ardwick Green. Brown was active in the 1920s, advertising himself as a 'postcard publisher', issuing real photographic cards of street scenes in the Manchester area. He sent images to a photoprinter for postcard production, using a mechanised photographic process. Handwriting on the backs of original photographs show that he sometimes gave instructions to the printer, such as elements of a scene being removed so as not to appear on the final published card. Two examples of local photographers producing photographs in postcard format by hand were Edward Ward, with a studio on Oxford Road, near Manchester University, and Berne Lancelot Pearson, a butcher's son who worked from Oldham Road, Newton Heath. Ward's father, also an Edward, had sold microscopy instruments and slides from the same address before his photographer son took over. The postcard reproductions in this book offer a selection of the many cards issued during the twentieth century – from producers large, medium and small. It is an annotated postcard album of Manchester.

SECTION 1
MEDIEVAL CORE

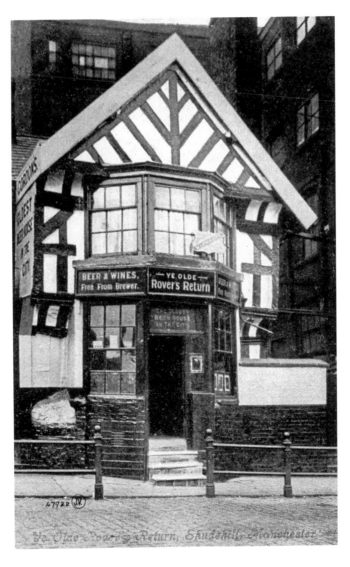

Rover's Return, Shudehill.

The Old Town and Victoria Street

Although the 'chester' in Manchester betrays a Roman past, the origins of the modern city were centred around what is now the cathedral. The compact site of medieval Manchester is captured in the top postcard. The CIS building of 1962 shares the frame with the ancient Chetham's School and Library. Victoria station is seen to the left, and the River Irwell is evident in the bottom-left corner. The lower postcard carries a publisher's code to suggest it was issued in the 1920s. The original photograph was probably taken from the Victoria Buildings, destroyed in the Second World War. Exchange station and its driveway are noted on the left, Cromwell's statue in the bottom centre, and Manchester Corporation trams on Victoria Street.

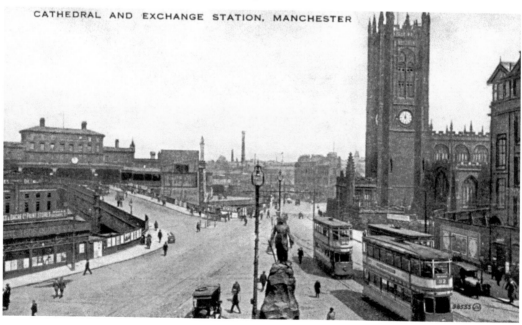

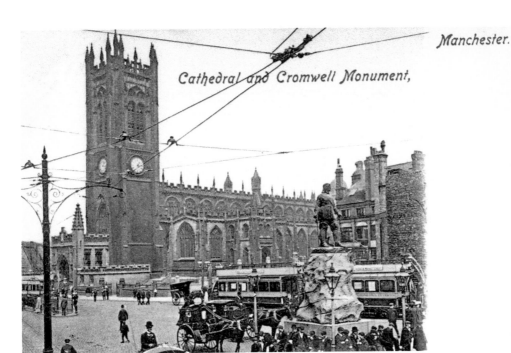

Manchester.

Cathedral and Cromwell Monument,

Manchester Cathedral

The two cards reproduced on this page show a contrast in production methods. The earlier, coloured card, published in Edwardian times, was printed in Saxony. The colour rendition, as here, could sometimes be more interpretive than accurate. The bottom card was posted in 1942, the sender making reference to 'horrible scars' around the city, commenting, it is assumed, on wartime bomb damage. This real photographic card was based on an image of several years before. The cathedral was designated as such in 1847. From 1421 it was known as the Collegiate Church, when the Lord of the Manor, Thomas de la Warre, applied to have the church become a college for priests.

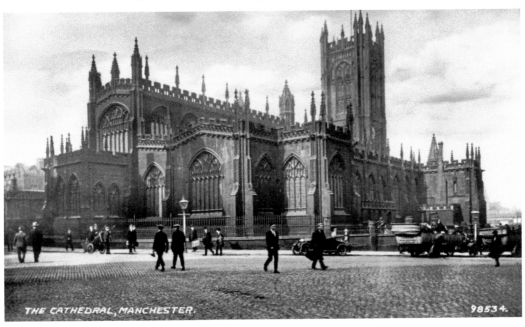

THE CATHEDRAL, MANCHESTER. 98534.

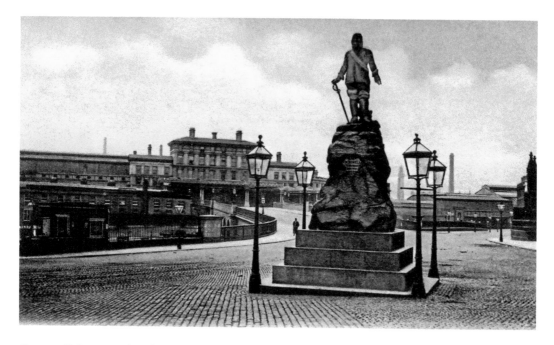

Cromwell Statue and Exchange Station

The statue, by Matthew Noble, was unveiled in 1875, nine years before the London & North Western Railway opened its Exchange station. Manchester had taken the Parliamentary side in the English Civil War and, in 1642, held out against a Royalist siege. Maybe Cromwell's siting was apt. The statue's base clearly offered a place of rest and congregation, as seen in the sepia card, which was mailed in 1912. Cromwell was considered a traffic impediment, and the statue was removed in the 1960s, to be relocated in Wythenshawe Park. Exchange station closed shortly after, in 1969.

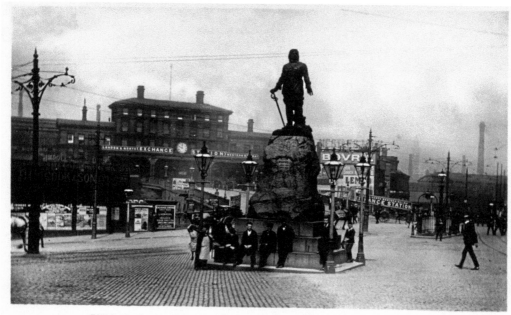

EXCHANGE STATION & CROMWELL MONUMENT, MANCHESTER

Chetham's College and Poet's Corner

Humphrey Chetham, a prosperous textile merchant who died in 1653, bequeathed money to establish a school (or 'hospital') for poor boys. He also left a bequest to establish a library, which still flourishes. The low buildings in the coloured card are of Chetham's Hospital. Some of its bluecoat scholars are also evident. In 1969, it became a specialist music school. The taller buildings in the background belonged to Manchester Grammar School, then also on Long Millgate. The card of Poet's Corner gives an idea of Manchester's domestic buildings before the industrial age. This former inn was demolished in the 1920s. On the left one of the Grammar School buildings can be seen.

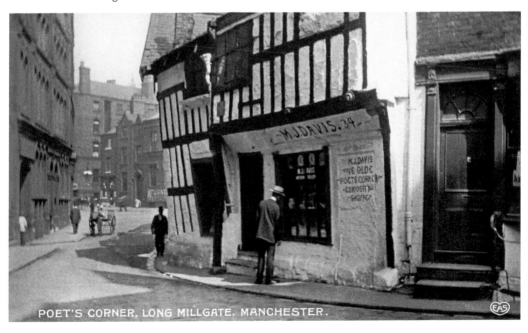

POET'S CORNER, LONG MILLGATE, MANCHESTER.

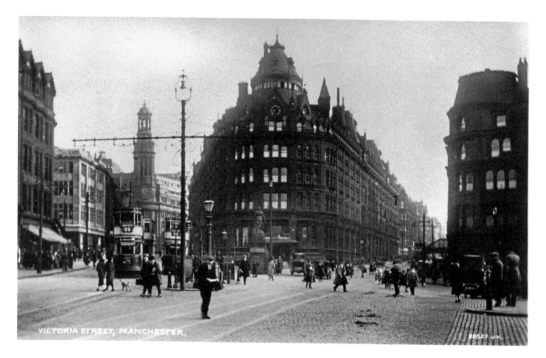

Victoria Buildings

The sepia postcard dates from around 1930. The camera is positioned on Victoria Street, aimed in the direction of Deansgate, which is the road directly ahead on the right. The road on the left where the trams are is a section of Victoria Street that has long ceased to exist. The central, dominant structure was called the Victoria Buildings, erected in the 1870s. There was a hotel, arcade, shops and offices. It was triangular in footprint, bounded by Deansgate, Victoria Street and St Mary's Gate. Bombed during the Second World War, the site was subsequently cleared. The tower of the Royal Exchange offers some help with orientation. The building on the right was another hotel, the Grosvenor. The postcard below was mailed in 1966, and shows a similar viewpoint.

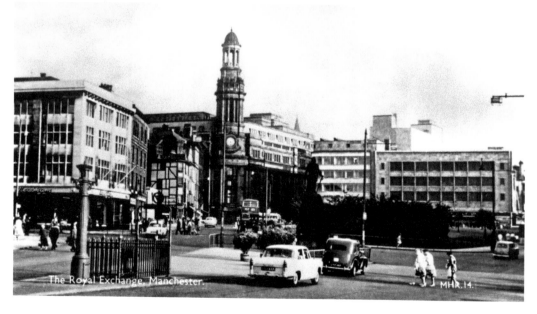

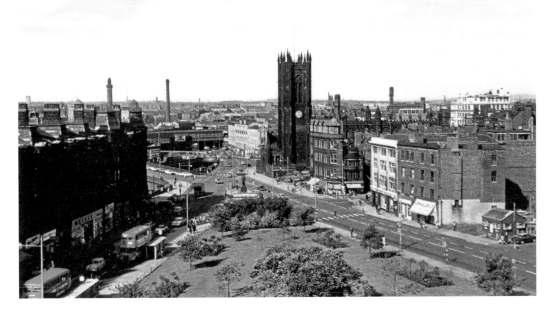

Landscaped Site of Former Victoria Buildings

A Manchester guide published in 1948 explained that the bombed Victoria Buildings site was to become a public garden. The two postcards on this page show, from opposite directions, how this 'garden' was laid out. The coloured card shows Deansgate to the left, with Manchester Corporation buses in their red livery, and the now lost section of Victoria Street on the right. At the apex of the landscaping, the Cromwell statue is still in place. The monochrome postcard was mailed in 1960. The group of buildings on the right of this card includes the one-time Deansgate Hotel. In the 1970s, this grassy sward was built over, creating a soulless concrete development, which included a footbridge across Deansgate.

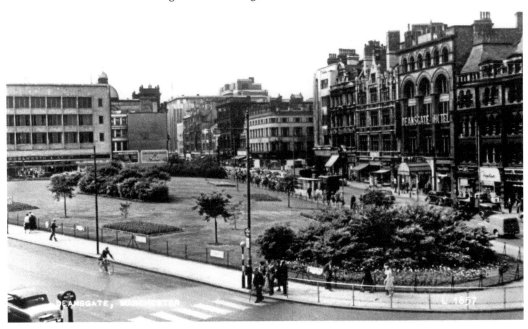

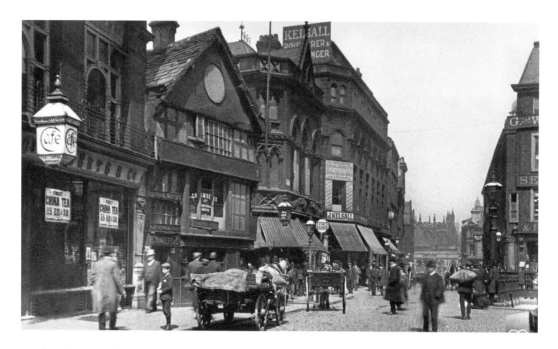

Market Place

By the early 1900s, Market Place had become just the name of a street rather than the description of a place for buying household essentials. The main street stalls had gone. There were, however, fish stalls by the side of the Wellington Inn, in an alley known as the Old Shambles. The gable end of the centuries-old Wellington Inn (with fishing tackle shop above) is seen in the sepia postcard, and more so in the coloured card. Market Place was badly damaged by Second World War bombing, although the Wellington Inn – surrounded by higher buildings – managed to survive. In the 1970s, the Wellington was jacked up around 5 feet and formed part of a public space, Shambles Square and a new Market Place.

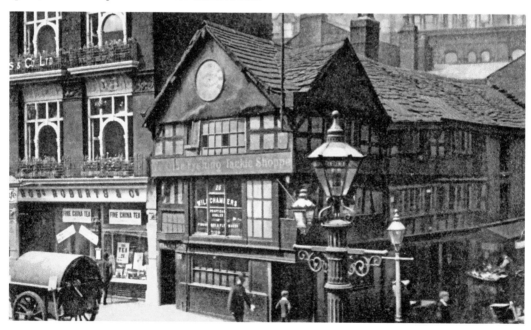

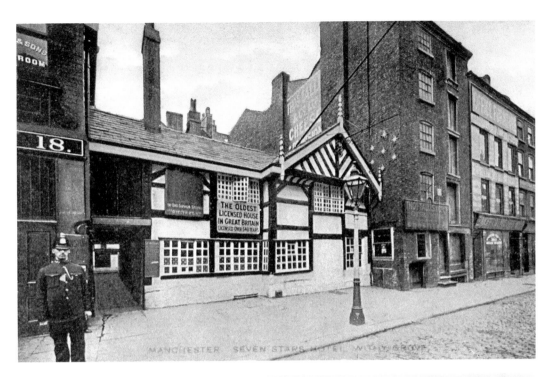

Seven Stars and Rover's Return

A visitor strolling up Withy Grove from Corporation Street in the early 1900s would have seen, on the right-hand side of the road, a curious anachronism among the commercial buildings of workaday Manchester. The Seven Stars Inn made claims for itself, such as being the oldest licensed house in Britain. There were also colourful legends attached to the place. However, despite letters of protest to the press in 1911, it was demolished that year. On to Shudehill, and another venerable hostelry, the Rover's Return. This claimed to be even older than its rival. The Rover's had also been pulled down by 1958.

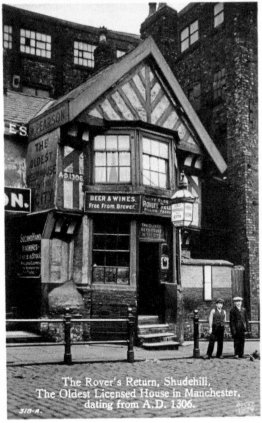

The Rover's Return, Shudehill.
The Oldest Licensed House in Manchester,
dating from A.D. 1306.

SECTION 2

BUILDINGS

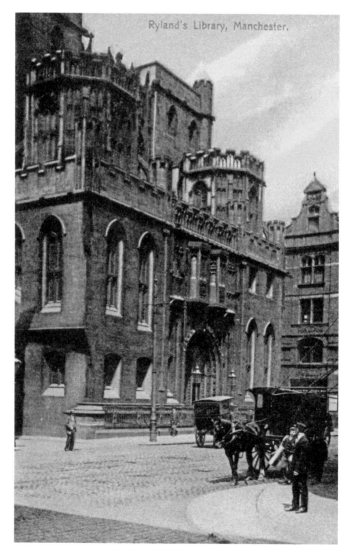

Rylands Library, Deansgate.

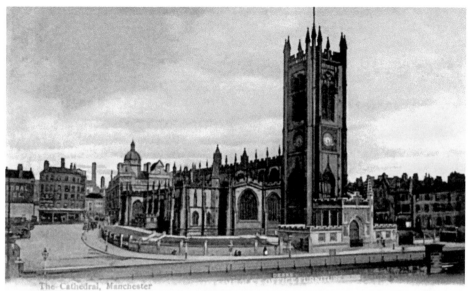

The Cathedral, Manchester

Photo by Graphotone Co.

Cathedral and Town Hall

The cathedral had undergone significant restoration during the nineteenth century. Between 1864 and 1868 the tower was rebuilt, and during the same decade there was large-scale resurfacing to the walls. A new west porch was added for Queen Victoria's 1897 Diamond Jubilee, designed by Basil Champneys, who also worked on Rylands Library. The card reproduced here was styled by the publisher as a 'Camera Graph', suggesting an interplay of photography and colour printing. The Town Hall has been a Manchester landmark since 1877, when architect Alfred Waterhouse's Gothic creation was formally opened. The card seen here was posted in 1910 and published as part of a set, each featuring the city crest.

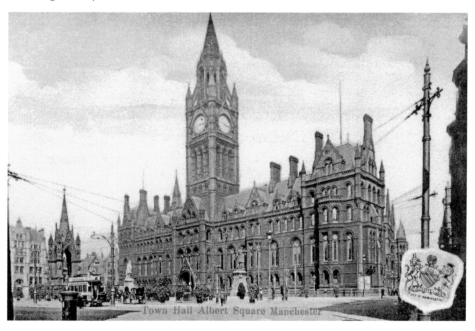

Town Hall Albert Square Manchester

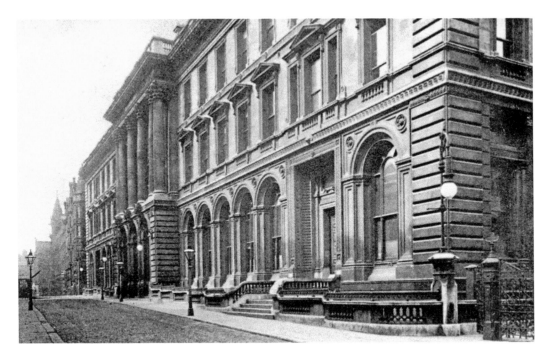

General Post Office

The General Post Office, depicted in these two postcards, was erected from 1881–87. It stood between Spring Gardens and Brown Street, and was built of Portland stone in an Italian style. The printed card, from just after 1900, shows the Spring Gardens elevation, with the main entrance. The interior view, from a real photographic card mailed in 1929, features a memorial to postal workers killed during the First World War. It was unveiled in the same year the card was sent. Seen as a memorial for peace rather than war, it was removed when the building shown on this page was demolished in the 1960s. The memorial was later resited and dedicated at the sorting office on Oldham Road.

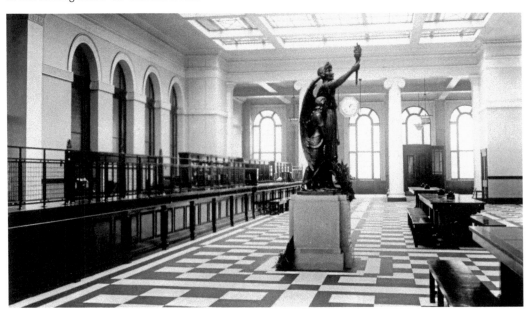

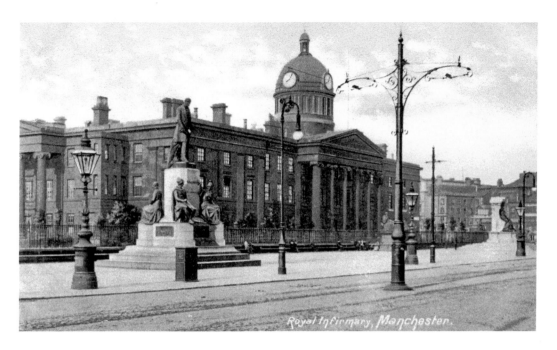

Royal Infirmary and City Art Gallery

The infirmary was founded in 1752, occupying premises in Garden Street, off Withy Grove. Within three years removal was made to this site, then on the edge of town. Over the years, additions and enlargements were made until, in 1908, patients were transferred to the new Royal Infirmary on Oxford Road. Down Mosley Street from the infirmary was the City Art Gallery. The building was designed by Charles Barry, who was later the architect for the Houses of Parliament. Erected in the 1820s for the Royal Manchester Institution, a body promoting art, science and literature, the building and art collection was passed over to the City Corporation in 1883.

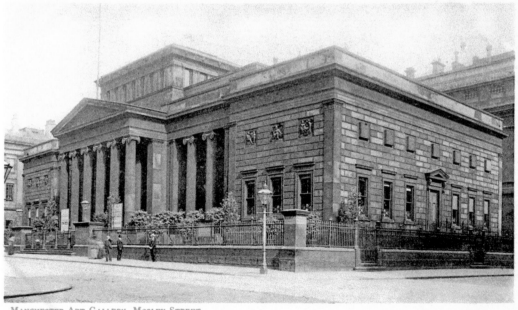

MANCHESTER ART GALLERY, MOSLEY STREET.

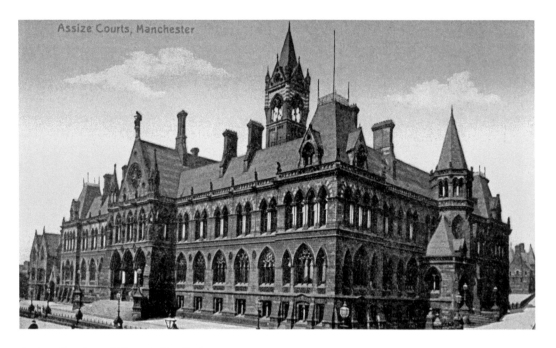

Assize Courts, Manchester

Assize Courts and Central Fire Station

The Assize Courts, which stood in front of the prison at Strangeways, heard the first cases in 1864, before the Lord Chief Justice. The architect, Alfred Waterhouse, designed the buildings in a Decorated Gothic style. Firebombed during the Second World War, the remains were described in 1956 as making 'a very impressive ruin'. Waterhouse had judged the architectural competition for the Edwardian fire station on London Road. It was completed in 1906, offering facilities for both fire and police personnel. The postcard, showing the junction with Fairfield Street, is in the form of a real photograph. It was produced by a local photographer, Arthur Harold Clarke, from Chorlton-cum-Hardy. Clarke was active in the 1930s, giving a possible vintage for this image.

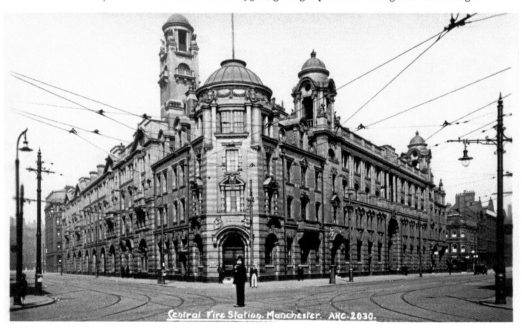

Central Fire Station. Manchester. AHC.2030.

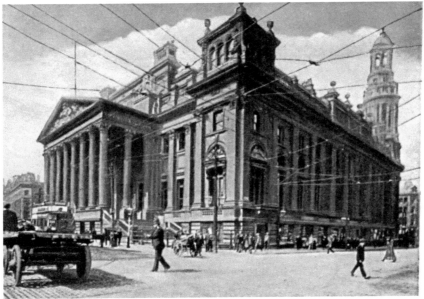

ROYAL EXCHANGE

Royal Exchange

Cotton, the former elemental industry of Lancashire, was embodied in the Royal Exchange. An exchange had been built on this site by 1809. Enlargement and rebuilding during the nineteenth century gave traders the building seen in the coloured postcard. The Royal Exchange's portico, with its double flight of steps and Corinthian columns, was affirmed by one writer in 1894 to be 'the most imposing in Manchester'. The apparent need for more floor space gave rise to yet another enlargement. This was carried out between 1914 and 1921, when the 'New Royal Exchange', as the sepia postcard describes it, was ceremonially opened by George V. Over subsequent decades trade slackened, and the last business was conducted in 1968. It is now a theatre.

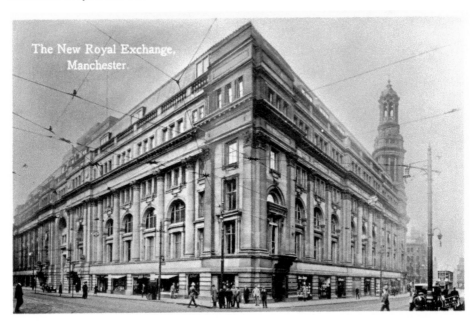

The New Royal Exchange, Manchester.

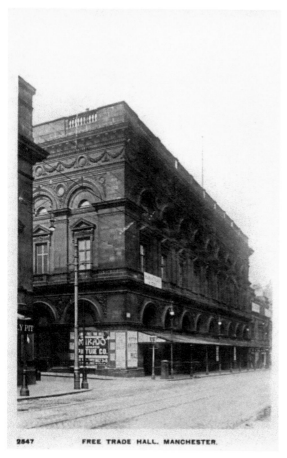

2547 FREE TRADE HALL. MANCHESTER.

Free Trade Hall and Municipal Technical School

This Free Trade Hall building dates from 1856 and stands on the site of the Radical meeting in 1819 that was broken up with loss of life, known as the Peterloo Massacre. The Hallé Orchestra made its home here, and political meetings have been hosted. In 1905 – around the date of the postcard – at a pre-election Liberal Party meeting, Christabel Pankhurst and Annie Kenney were ejected for challenging senior Liberal Edward Grey about votes for women. The Municipal Technical School building was opened in 1902 by Arthur Balfour, prime minister and a Manchester MP. A new and imposing structure, it was an ideal subject for Edwardian postcard publishers.

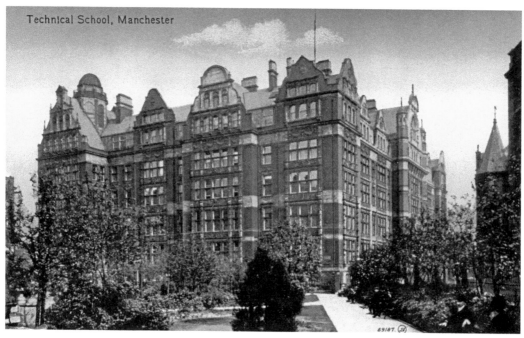

Technical School, Manchester

69187. (N)

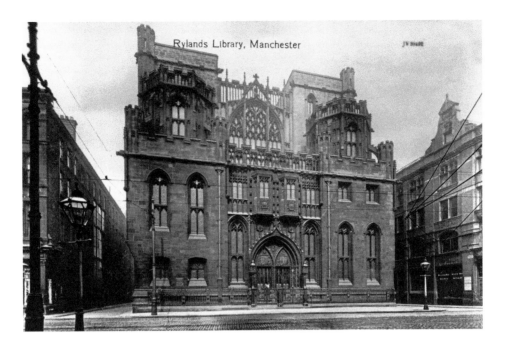

Rylands Library, Manchester

Rylands Library and Central Reference Library

The sepia postcard of Rylands Library dates from before the First World War. The view shows the Deansgate frontage, with Spinningfield to the left and Wood Street on the right. Enriqueta, the widow of wealthy textile manufacturer John Rylands, commissioned this building to house the religious books he had collected, plus those from subsequent purchases. The architect chosen was Basil Champneys, and the building was ready by 1899. It is now part of Manchester University. The card of the Central Library was posted in 1985, so Metrolink has yet to arrive in St Peter's Square. This library was opened in 1934, following the use of huts in Piccadilly. (Central Library postcard © John Hinde Archive)

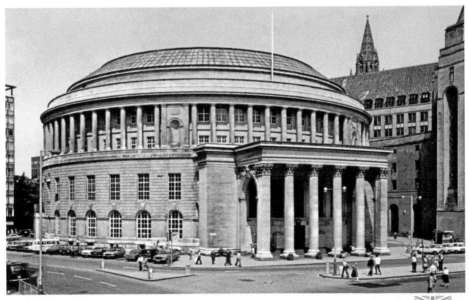

Library, St. Peter's Square, Manchester

M 0262

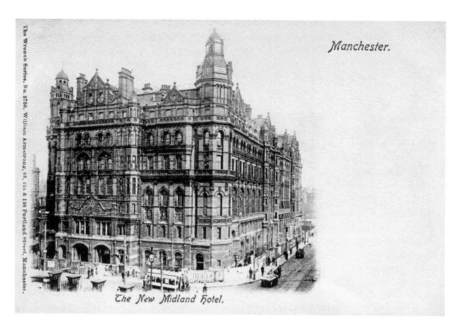

Midland Hotel and Old Wellington Inn

The Midland Hotel, with its visual impact, had opened in 1903 and was, therefore, a popular postcard subject for Edwardian publishers. In this view, from Lower Mosley Street, hoardings are still in place, so there is still building work to do. The card was produced by John Evelyn Wrench, a London-based publisher who has supplied a Portland Street retailer called William Armstrong. The card of the Old Wellington Inn was posted in 1993, three years before the IRA bomb devastated so much. The Wellingon Inn and Sinclair's Oyster Bar were raised up 5 feet to be part of this 1970s development called Shambles Square. The Wellington and Sinclair's have since been relocated, and the background, seen here, demolished. (Wellington Inn postcard © John Hinde Archive)

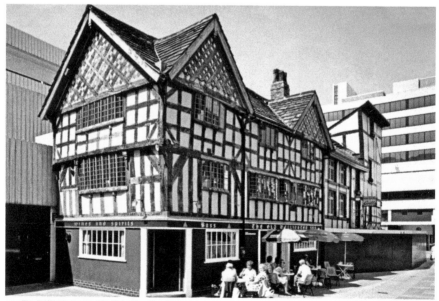

The Old Wellington Inn, The Shambles, Manchester

M.002063L

SECTION 3
CITY SQUARES

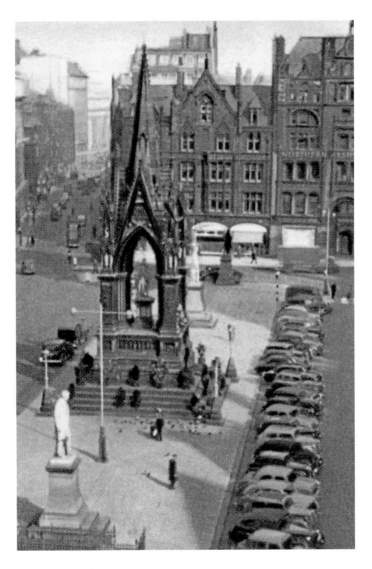

Albert Memorial, Albert Square.

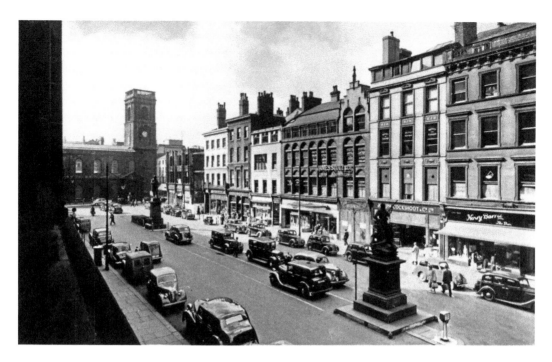

St Ann's Square

Originally known as Acres Field, the land of the future St Ann's Square was the site of an annual fair, which was granted in 1227 and survived here until the nineteenth century, when it was relocated. The current name derives from St Ann's Church, which was consecrated in 1712. The square became a fashionable residential address, but by 1878 one writer noted that 'private residences have given way to public establishments'. In 1832, hustings for the town's first reformed parliamentary election took place by the church. The sepia postcard, mailed in 1907, shows an oddly empty St Ann's Square. The hut is possibly a cab drivers' shelter.

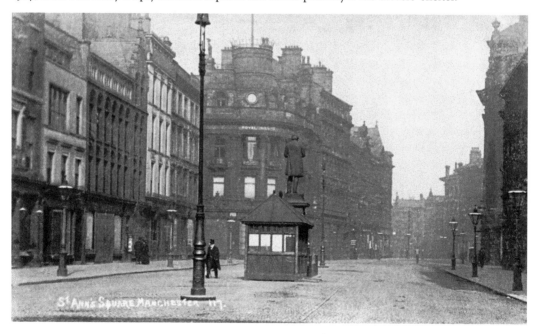

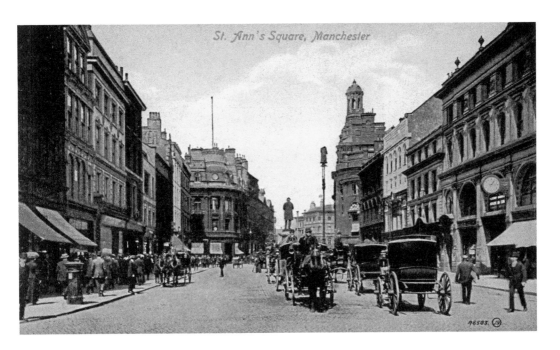

St. Ann's Square, Manchester

St Ann's Square and Exchange Street

The coloured postcard shows several horse-drawn cabs. Hackney carriage stands had been here since 1810, and postcards from different years show the changeover from equine cabs to motorised taxis. Exchange Street is a continuation of St Ann's Square. The sepia postcard, mailed in 1911, reveals a scene long disappeared. It was photographed from the junction of Exchange Street, Market Street (to the right) and St Mary's Gate (left). It is possible to make out the cathedral tower in the distance, although the rest has nearly all gone. The rounded structure on the left is one corner of the Victoria Buildings, destroyed in the Second World War. Directly ahead is a portion of Victoria Street that is also lost.

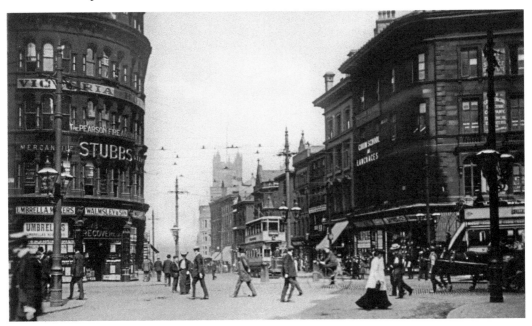

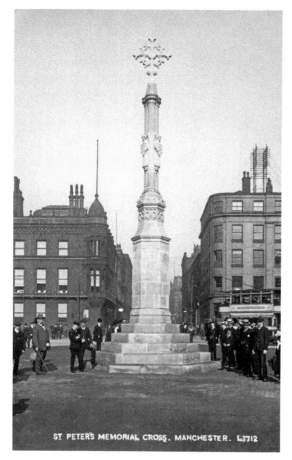

ST PETER'S MEMORIAL CROSS. MANCHESTER. L.3712

Cenotaph and St Peter's Memorial Cross

St Peter's Church, which gave the square its name, held its final service in August 1906 and was demolished by the following year. It had been consecrated in 1794, but by Edwardian times the parish had become commercial rather than residential and so could not sustain a congregation. A memorial cross, seen here around the time of its dedication in 1908, was erected on the site. The cenotaph was unveiled in 1924. The cenotaph postcard was issued by James L. Brown, a publisher of Manchester region cards, who worked from business premises near Ardwick Green. Brown had asked his card printer to 'block' certain people to 'improve' the composition. However, comparing original photograph and published card, shows they remained unblocked.

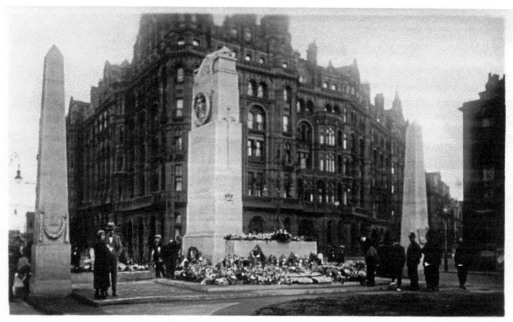

THE CENOTAPH. ST. PETERS SQUARE. MANCHESTER 318. C J. L. B. SERIES

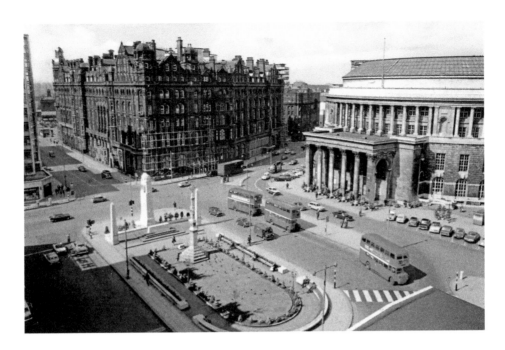

St Peter's Square

The two postcards on this page are from the 1960s. They show, in context, the Central Library and Town Hall extension, which altered the scale of architecture on that side of the square. These buildings were designed by Emanuel Vincent Harris as a composite whole, despite different architectural styles. The library was opened by George V in 1934 and the extension four years later by George VI. The red-brick and terracotta Midland Hotel of 1903 dominates the corner of Lower Mosley Street and Peter Street. On the site of the demolished St Peter's Church we see the traffic island with the cenotaph, St Peter's Cross and lawn. Each card also captures a trio of red Manchester Corporation buses.

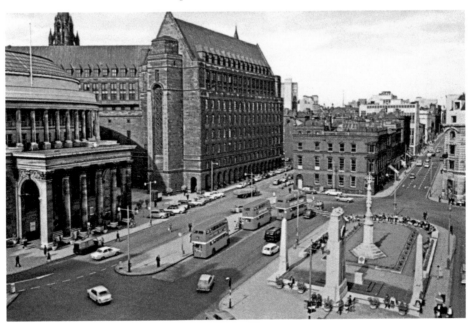

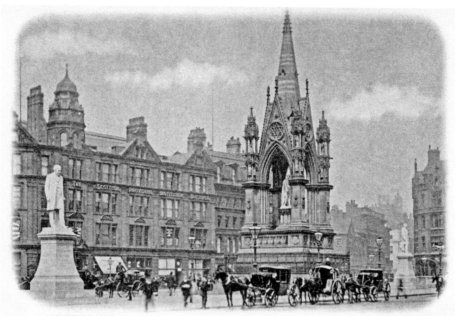

ALBERT SQUARE. MANCHESTER.

Albert Square

The idea for placing a memorial to the recently deceased Prince Albert here was heard by the Corporation's Improvement Committee in 1863. The area was to be cleared, then laid out as a spacious square. Siting the memorial in Piccadilly had already been rejected, but there was also dissent over the new proposal. It was suggested that squares should be made in densely populated areas, such as Ancoats and Oldham Street. In the event, the Albert Memorial was built here. The canopy was designed by Thomas Worthington and the statue sculpted by Matthew Noble. The memorial was formally presented to Manchester in 1867. Other statues appeared later, as can be seen in both postcards.

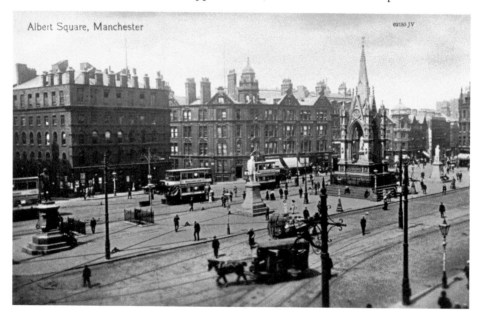

Albert Square, Manchester

Town Hall and Mount Street

The Town Hall postcard was mailed in 1966, and gives an idea of how traffic, including public transport, could once circulate around the elongated central island and its statuary. In earlier years there were tram lines in Albert Square. Alfred Waterhouse won the design competition for the new Town Hall, which was ceremonially opened in 1877. The 1930s view from Mount Street shows the Town Hall tower and construction work on the new Central Library. It is also just possible to make out buildings that were demolished for the Town Hall extension. This image is from a photograph printed on standard postcard stationery, although it does not seem to have been produced for retail sale.

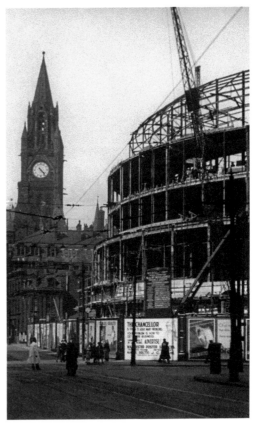

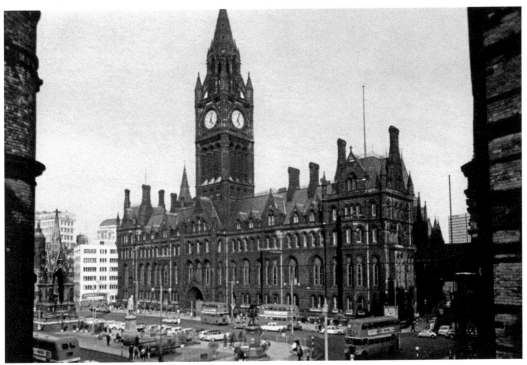

SECTION 4
PICCADILLY

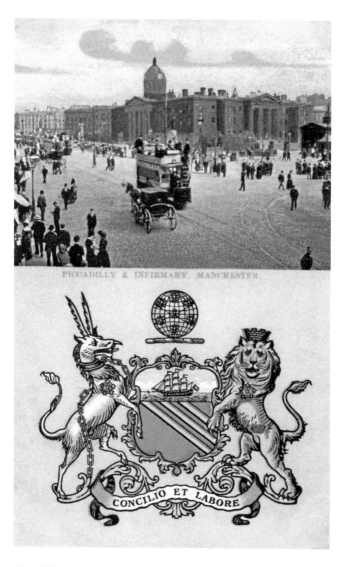

Piccadilly and coat of arms.

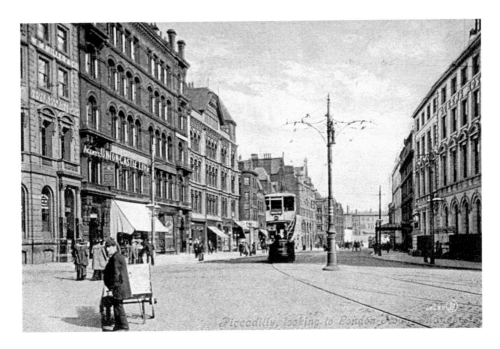

Piccadilly and Royal Infirmary

Maps published in the late eighteenth century give the name of that part of modern Piccadilly lying between Portland Street and Market Street as Lever's Row (after landowner Sir Ashton Lever). Piccadilly was limited to the road between Portland Street and what is now the approach to Piccadilly station. By around 1812, the current naming was adopted. The tinted postcard, mailed in 1907, shows the original section of Piccadilly, albeit with later buildings and transport. The sepia card was sent in 1914 from Bolton to Prestwich. It was bought, according to the message, at the book stall on Victoria station. It seems that the recipient was 'on the lookout for a view of the old building'. The Royal Infirmary in Piccadilly had been demolished four years by the time of posting.

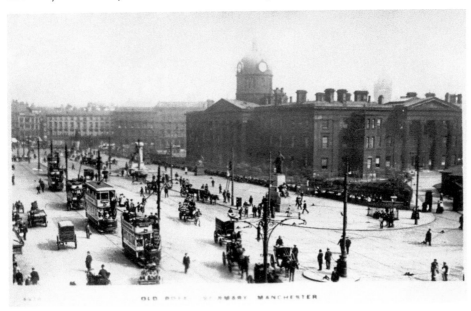

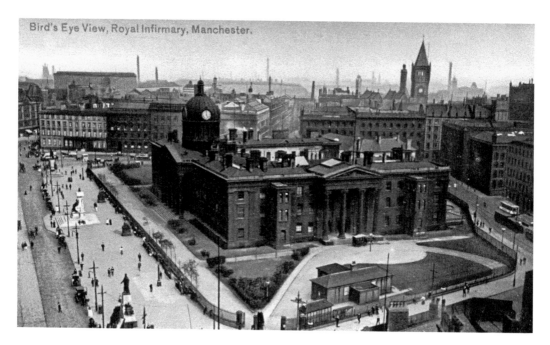

Bird's Eye View, Royal Infirmary, Manchester.

Royal Infirmary

The infirmary had moved to this location from Garden Street, Withy Grove, in 1755. Before the end of that century, the hospital had been augmented by public baths, a dispensary and what was then termed a lunatic asylum. A local guide from around 1850 states that the building 'forms one of the greatest ornaments of the town'. A visitor in Edwardian days, though, commenting on Manchester's sooty garb, wrote that the 'blackest blackness of all, however, is that of the great Infirmary'. The building was vacated in 1908, and pulled down two years later. The card with the city crest and motto was from a set of matching issues, published by C. W. Faulkner & Co., a major London-based firm.

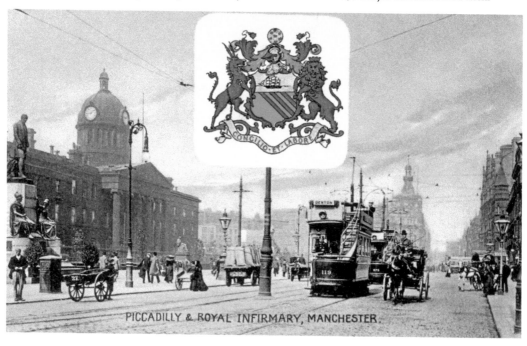

PICCADILLY & ROYAL INFIRMARY, MANCHESTER.

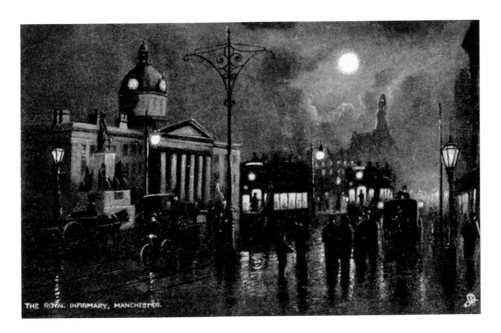

THE ROYAL INFIRMARY, MANCHESTER.

Raphael Tuck Cards of Piccadilly

Postcard publishers in the early 1900s could range in scale of operation from studio photographers producing local view cards by hand in limited runs, using traditional developing and printing processes, up to large-scale companies with rotary printing presses and legions of employees. The London firm of Raphael Tuck was one of the giants. They were influential in getting the British postal authorities to accept larger cards in 1899, so that postcard artists and designers had more scope for their work. This led in turn to a more appealing product and stimulated the Edwardian postcard mania. Tuck used various trade names to characterise their card styles and finish. Probably their best known was the Oilette range, intended to suggest the look of an oil painting. Here we see two Manchester Oilettes.

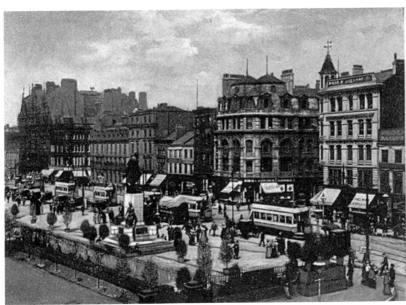

PICCADILLY,
MANCHESTER

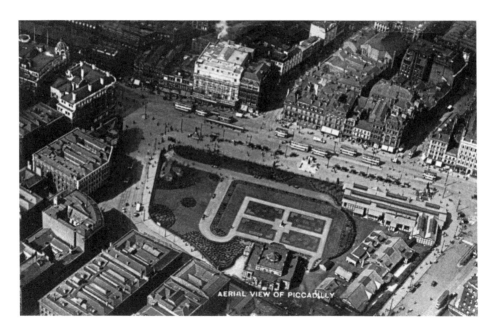

AERIAL VIEW OF PICCADILLY

Aerial Views of Piccadilly

The sepia card was mailed in 1924, and the black and white in 1928. This does not, however, mean that the photographs were taken in those years. The earlier view reveals some building work going on near Oldham Street, which runs off at an angle near the top centre of the photograph. To the street's left, the standout light-coloured building is the Piccadilly Cinema, here still under construction. The Albion Hotel is on the right-hand corner of Oldham Street, shortly to be demolished. On the right of the gardens, at the angle with Portland Street, the temporary huts that then housed the reference library are seen. The later card shows the Piccadilly Cinema now open but a little weathered. The new Woolworth's store, rising on the site of the former Albion Hotel, is yet to be completed, with builders' hoardings at street level.

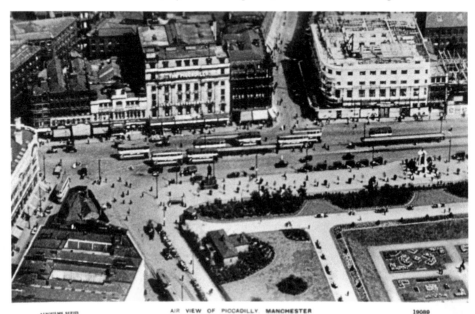

AEROFILMS SERIES AIR VIEW OF PICCADILLY MANCHESTER 19089

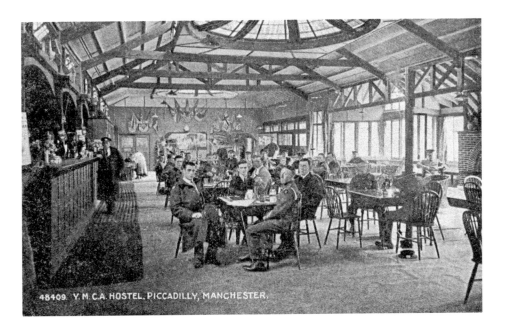

48409. Y.M.C.A. HOSTEL, PICCADILLY, MANCHESTER.

YMCA Hostel and Mosley Hotel

Messages on the backs of postcards can sometimes hint at a fragment of big history acted out on a personal scale. The card of the YMCA servicemen's hut at Piccadilly Gardens, posted towards the end of 1918, was sent by a private serving with a Canadian battalion. He was writing from an address in Moston to a female in Hove. He wishes her New Year greetings, then adds, 'Please Write'. The other card, sent in 1913, shows a street scene outside the Mosley Hotel (demolished for the 1920s Piccadilly Cinema), and was published locally, very locally. It was issued in the Lever series by John E. Nancarrow, who was a printer and stationer in Lever Street, just off Piccadilly. It was sent to a French address in the Somme region, explaining that the writer, possibly English, was returning to France to work in a mill.

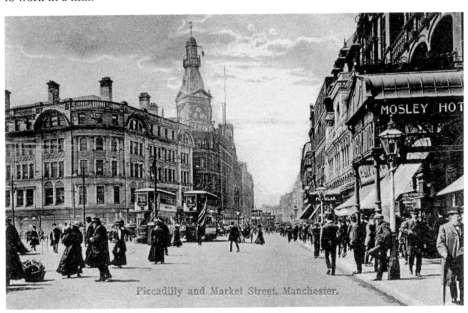

Piccadilly and Market Street, Manchester.

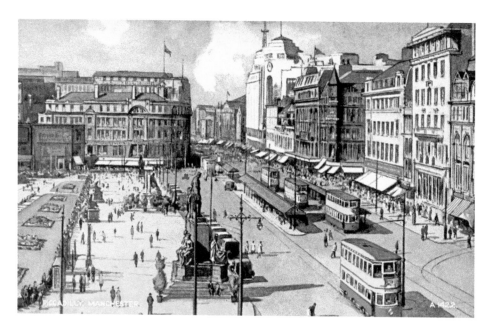

Piccadilly Esplanade and Gardens

The artist-originated card on this page was produced by Valentine & Sons, one of the most prolific of postcard publishers from the early years to the 1960s. Their UK printing works were in Dundee, from where they turned out an enormous quantity of cards. Although they produced cards on various themes, they were best known for view postcards. Manchester had its goodly share of Valentines from Edwardian times on. The reproduction seen here is described as an 'art colour' postcard from a water colour by Edward Hailey. The Esplanade is directly ahead, with Piccadilly Gardens to the left. The sepia card shows not only the gardens, but also warehouses on Parker Street that were destroyed during Second World War bombing. The building on the left remained after the main infirmary was demolished. It was used as a city centre casualty department.

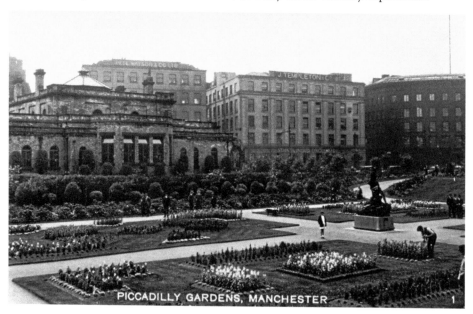

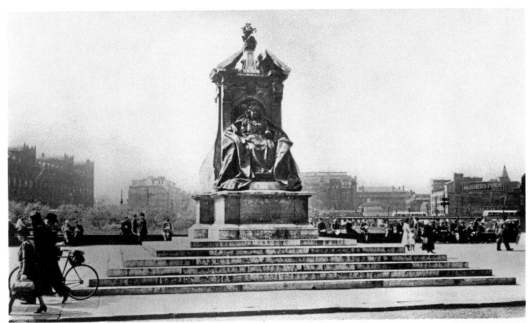

61691. MANCHESTER. QUEEN VICTORIA STATUE.

Victoria Statue and Cleared Bomb Site

The views on this page are from cards of the 1940s. The postcard of the Victoria statue, unveiled in 1901, was intended to highlight that piece of sculpture; however, what appears more revealing, is the background. After the bomb destruction had been cleared from the Parker Street site, the Corporation was left with an open space, which can be just made out on the other card. It was used as a car park for a while, before redevelopment in the 1960s. The card below also offers part sight of a trolleybus, that hybrid vehicle of bus and tram. Electric power was taken from wires above, but it ran on steerable wheels rather than tracks. Manchester abandoned them in 1966.

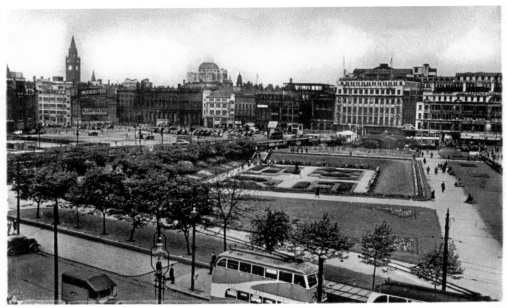

61685 PICCADILLY. MANCHESTER.

39

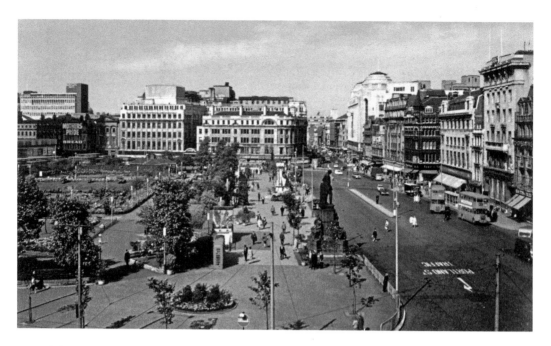

Piccadilly Esplanade and Plaza

The top postcard was mailed in 1966, and offers a view along the Piccadilly Esplanade similar to the Valentine's 'water colour' card, although over twenty years later. The Esplanade was laid out with fountains in the 1850s, on the site of what had been the infirmary pond. The same decade gave Piccadilly the statues of John Dalton, Robert Peel, the Duke of Wellington and James Watt. The second card shows the result of the Piccadilly Plaza development of the 1960s, built on the site of the bombed-out warehouses fronting Parker Street. The tallest building was then called Sunley Tower. On its left was the Hotel Piccadilly, and on the right, the eccentric Bernard House.

SECTION 5
CITY CENTRE STREETS

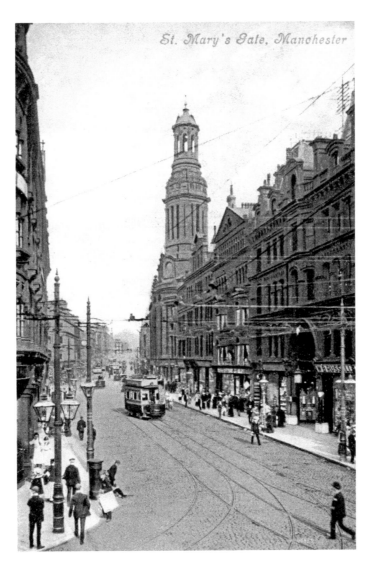

St Mary's Gate.

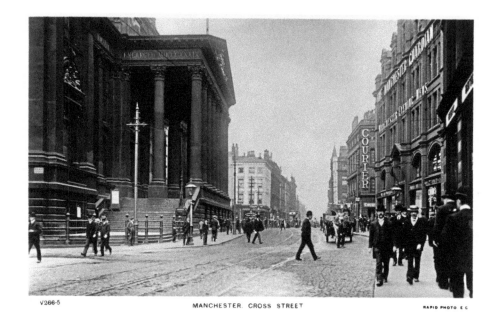

V266-5 MANCHESTER. CROSS STREET RAPID PHOTO E C

Cross Street

The photographic postcard gives a sight of Cross Street in its Edwardian pomp. On the left, the imposing portico of the Royal Exchange led cotton dealers into the building and onto the trading floor, at a time when Lancashire's defining industry was strong and flourishing. Rebuilding and enlargement of the Exchange between 1914 and 1921, saw the floor area increased and the street frontage streamlined, with the loss of this eye-catching feature. Across the road are the offices of the *Manchester Guardian* and *Manchester Evening News*. At this time, the *Guardian* was edited by C. P. Scott, a journalist with Liberal political views and an influential national voice. Further along the street, it is possible to make out a *Manchester Courier* branch office. A Tory rival to the *Guardian*, this paper lasted until 1916. The art card, fanciful in its depiction, suggests the street in the 1930s.

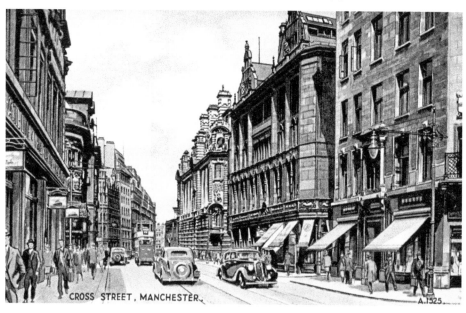

CROSS STREET, MANCHESTER A.1525

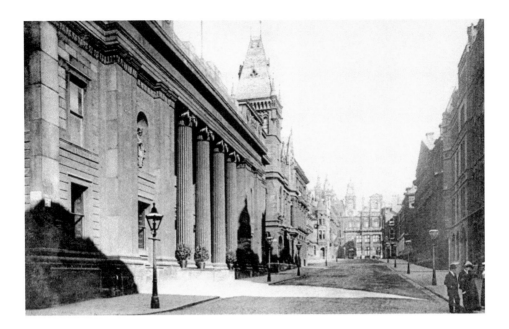

King Street

This street is cut in two by the intersection of Cross Street. The view in the monochrome postcard from the early 1900s shows, on the left, the former Town Hall building that stood on the Cross Street junction. At the time the card was issued, this building was being used as the city's reference library. It had been built for the Police Commissioners, who acted in a local government role that included street lighting and cleansing, as well as providing a night watch. The foundation stone had been laid in 1822, and three years later the building was ready. After the new Town Hall was opened in 1877 this building became the main library. It was demolished in 1912, although the columns were saved and moved to Heaton Park. The coloured card, also Edwardian, was produced by Boots Cash Chemists as one of a set. It shows the shopping section of the street.

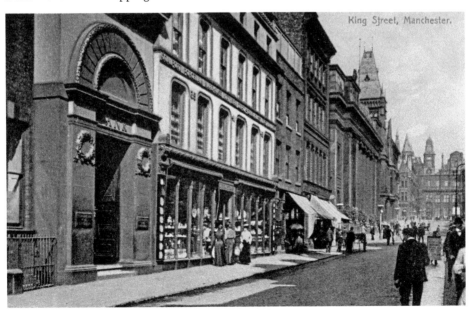

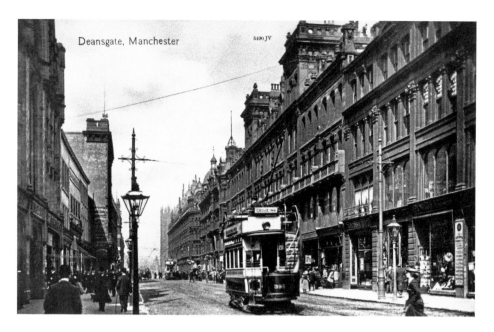

Deansgate, Manchester

Deansgate

Deansgate is one of Manchester's oldest thoroughfares and is shown on the earliest maps of the town. It didn't always take this name for the whole length. Laurent's plan of 1795 has the section near Castlefield called Alport Street. Following an Act of Parliament in 1869 to 'widen and alter Deansgate', it was transformed from a 'narrow, irregular, and inconveniently crowded street' to become an imposing city centre road. New architecture, including Barton's Buildings and the Victoria Buildings, had appeared by the 1870s. The two real photographic postcards on this page were published by Valentine & Sons of Dundee. The one looking north, towards the cathedral, is Edwardian. The second card, posted in 1924, looks south from the junction with St Mary's Gate on the left. The tram tracks on the right show rails heading towards Blackfriars Bridge and Salford.

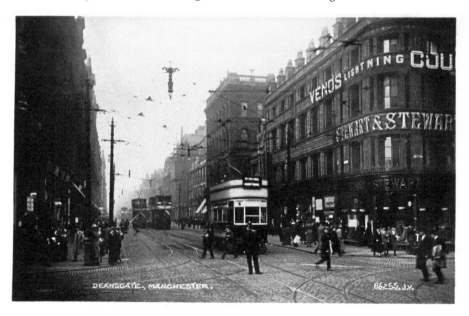

DEANSGATE, MANCHESTER.

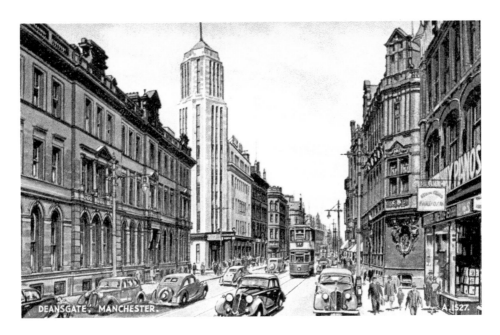

DEANSGATE, MANCHESTER.

A.1527.

Deansgate

The postcards on this page show Deansgate before and after the Second World War. The coloured card, another in Valentine's Art Colour set, is by artist G. W. Blow. Prominent in the image is the tower of Northcliffe House, the home of Associated Newspapers, publishers of the *Daily Mail*. The original building of 1904 was given an art deco makeover in around 1931, with its tower heightened to what is seen here. The building was demolished in 2002. The monochrome postcard gives a 1950s view. The camera is pointing south and the trams have gone. In the middle distance, the standout building is that of Kendal Milne's store. This has been a landmark since 1940, although the company has a much longer history on Deansgate. The Northcliffe House tower is in the far distance.

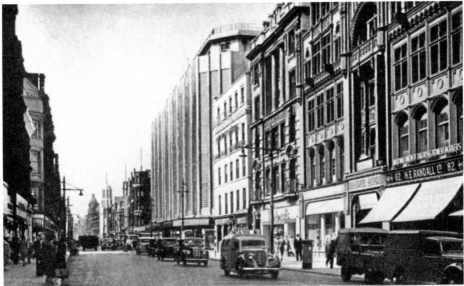

MANCHESTER, DEANSGATE.

V.3202

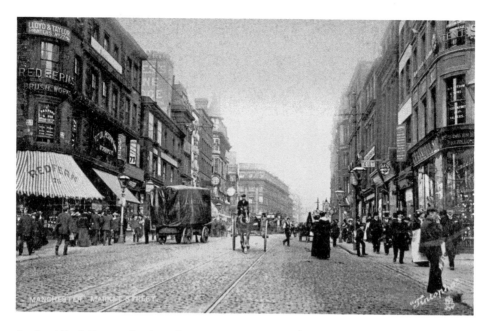

Raphael Tuck Postcards of Market Street

The top postcard was produced by Tuck in a finish given the name 'tintopho'. The detail of the original photograph remains sharp, but is given a two-colour tinting. The second card is in a style that Tuck called 'charmette', with more artwork on the photograph. Both were printed in Holland. Market Street, once called Market Stead Lane, goes back to medieval times. By the early nineteenth century it was narrow and crooked, rising from west to east. In 1821, a parliamentary Act was obtained to remedy matters. Special commissioners were appointed to oversee the widening, straightening and levelling. In the second half of the century, substantial commercial buildings appeared on the street, which can be seen on these Edwardian cards.

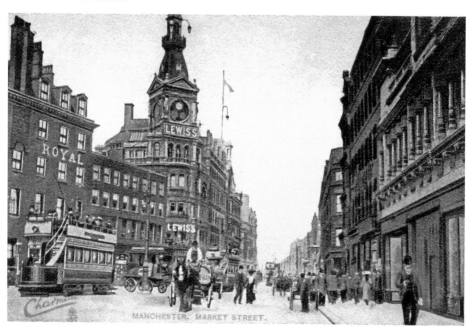

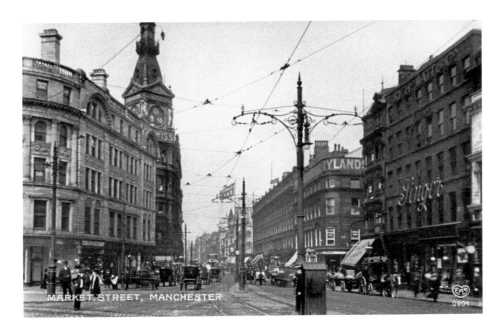

Market Street

The real photographic sepia card was posted in 1913. Lewis's store, with its digital clock tower, dates from 1880. The tower was removed, however, during subsequent remodelling of the store. The building to its left stands on the site of the Royal Hotel, which was demolished in 1908. The Rylands building is facing Lewis's, a warehouse for that major textile firm. It was replaced in the early 1930s by a much larger and street-dominating Portland stone Rylands building. This later became Paulden's, then Debenhams. The buildings in the far distance were lost to the Arndale Centre. The coloured card, mailed in 1909, was produced by a London publisher, Woolstone Bros. The view is from High Street, looking towards Piccadilly. The old Rylands building is on the left, with the display windows of Lewis's, opposite.

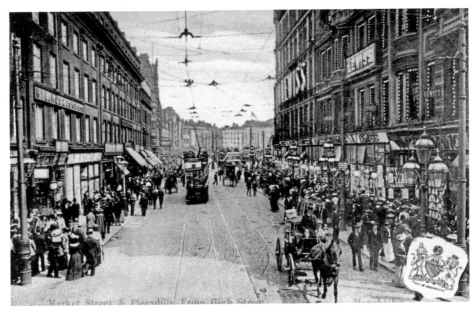

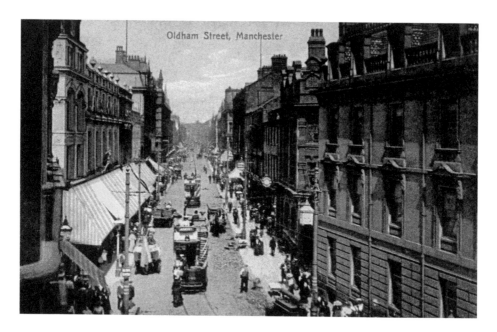

Oldham Street

This street was named in the eighteenth century after Adam Oldham, a hat manufacturer and Methodist acquaintance of John Wesley. The present Oldham Road was then called Newton Lane, so there is no name link. Oldham Street became the hub of Methodism in Manchester, with its central hall. By Edwardian times, when the coloured postcard was mailed from Altrincham to London, the street had become an important shopping venue. Affleck & Brown, the Oldham Street department store, stated in a 1940s advertisement that its then chairman was a grandson of the founder, the family having run the business for over eighty years. Other Edwardian retailers included the bookshop started by Chartist and publisher Abel Heywood, and Marks & Spencer's Penny Bazaar. The Albion Hotel, on the right of the frame, was demolished in the 1920s for the Woolworth's store seen in the 1930s sepia card.

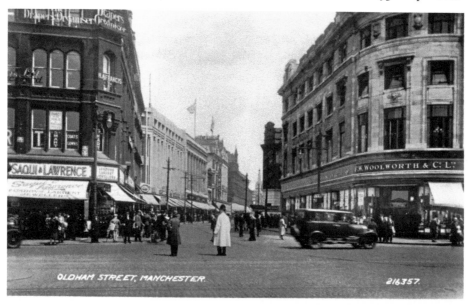

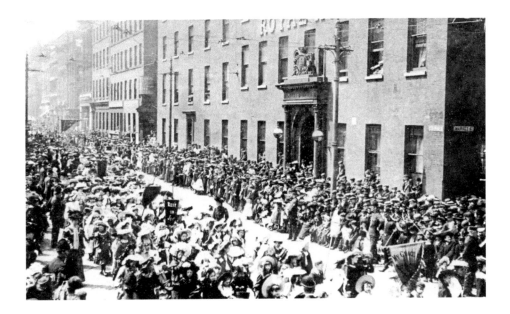

Mosley Street

Writing in 1881, one observer of Mosley Street noted that no street had changed so much in the previous fifty years. It had been 'quiet, orderly, genteel', the 'abode of some of the elite of Manchester'. Since, it had become the location of warehouses and witnessed the flow of constant traffic. By the new century, things had not changed much. The City Art Gallery, on the corner of Princess Street, was popular with postcard publishers. The coloured card is typical, even if the street name has a spelling mistake! The photographic card, posted in 1905 and capturing a street procession with watching crowds, shows the junction with Market Street. The nearest building is the one-time Royal Hotel, demolished a few years later. It was here that the Football League was founded in 1888.

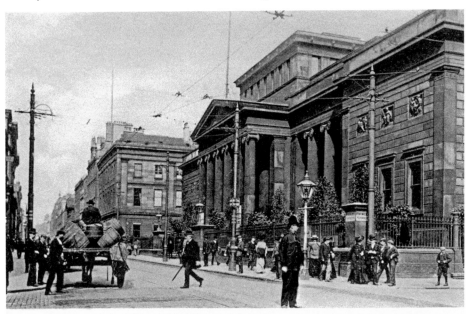

MOSELEY STREET & ART GALLERY, MANCHESTER.

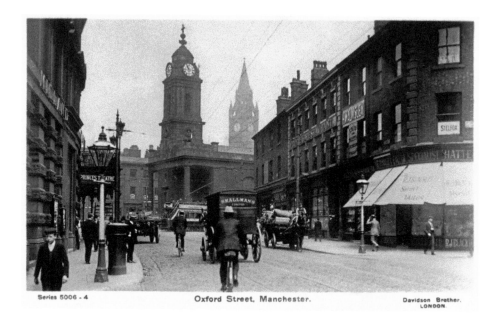

Oxford Street, Manchester.

Oxford Street

The top postcard shows an Edwardian scene in which the buildings are all now gone, except for the Town Hall clock tower in the far distance. The camera is directed at St Peter's Square from Oxford Street. The nearer tower belongs to St Peter's Church, which was demolished by 1907. Both clocks give the same time, 10.55! On the left it is possible to make out the sign of one of Manchester's lost theatres, the Prince's, which closed in 1940. The other card is from the 1920s. The Hippodrome variety theatre, which opened in 1904, is prominent on the left. It would survive into the 1930s, when a cinema was built on the site. In the distance, St Peter's Square has its cenotaph, but the Central Library has not yet been built.

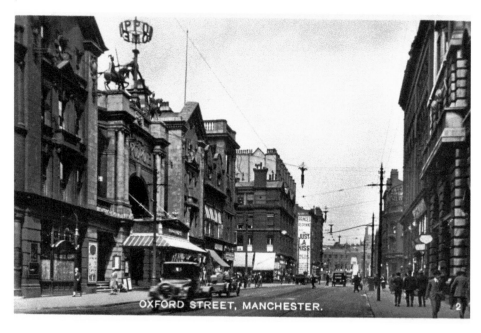

OXFORD STREET, MANCHESTER.

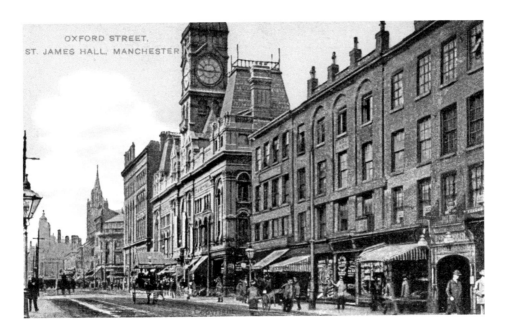

Oxford Street

In the early 1900s, heading along Oxford Street from St Peter's Square towards Whitworth Street, the St James's Hall would have come into view on the left side of the road. This was late Victorian and Edwardian Manchester's main indoor exhibition and bazaar venue. There was also a theatre in the building complex, with its own Oxford Street entrance. Before purpose-built cinemas, film shows were screened at the St James's. It was demolished for the St James's Building, built in 1912 for the Calico Printers' Association. The lower postcard shows Oxford Street at the Whitworth Street junction (on the right). On the left, designed by Alfred Waterhouse, was one of the St Mary's Hospital buildings. The Palace Theatre, which opened in 1891, is on the opposite side of the road.

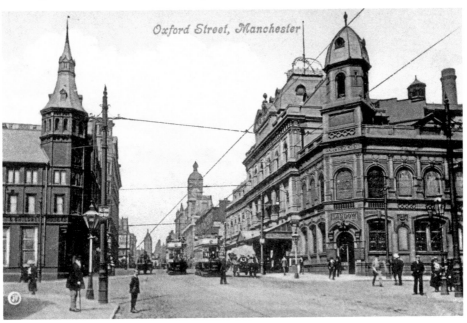

SECTION 6
BUSINESSES

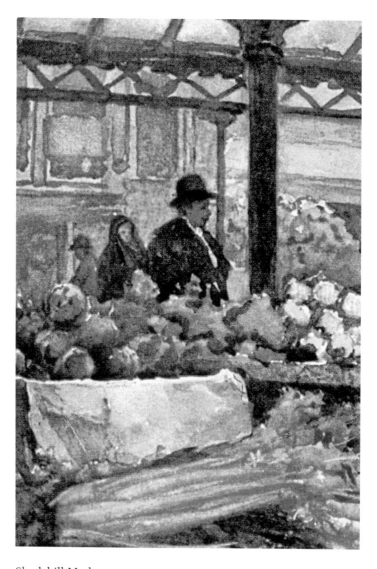

Shudehill Market.

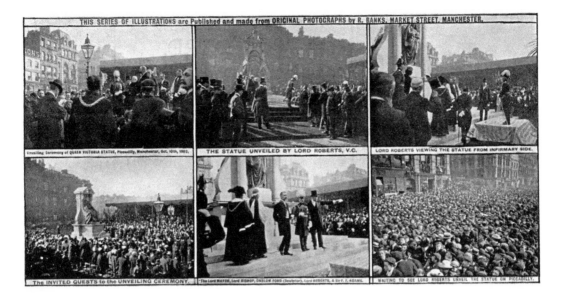

THIS SERIES OF ILLUSTRATIONS are Published and made from ORIGINAL PHOTOGRAPHS by R. BANKS, MARKET STREET, MANCHESTER.

Unveiling Ceremony of QUEEN VICTORIA STATUE, Piccadilly, Manchester, Oct. 10th, 1902.

THE STATUE UNVEILED BY LORD ROBERTS, V.C.

LORD ROBERTS VIEWING THE STATUE FROM INFIRMARY SIDE.

The INVITED GUESTS to the UNVEILING CEREMONY.

The Lord MAYOR, Lord BISHOP, ONSLOW FORD (Sculptor), Lord ROBERTS, & Sir F. F. ADAMS.

WAITING TO SEE LORD ROBERTS UNVEIL THE STATUE ON PICCADILLY.

Robert Banks, Photographer

Thanks to James Stanhope-Brown's book *Manchester from the Robert Banks Collection* we now have an appreciation of the work produced by this local photographer. Between 1874 and 1914 he rented various studios around the city. As well as making routine studio portraits, he recorded significant events in Manchester. One of these was the unveiling of the Queen Victoria statue in 1901. The postcard reproduced here shows a series of panels depicting scenes from the ceremony. On the reverse, is rubber stamped, 'A SAMPLE of the many Picture Postcards published by R. BANKS'. The studio address is given as No. 126 Market Street. Banks also took the original photographs for other card publishers. The real photographic card, posted in 1908, was created by Banks for the Co-operative Wholesale Society's biscuit factory at Crumpsall. His studio was then given as in Fountain Street.

AUTUMN FASHIONS DISPLAY IN THE **C.W.S.** SOCIETIES CUSTOMERS' DEPT., MANCHESTER.

CWS Fashions and Mabbs Electrics

The picture postcard was a useful device for promotional purposes. The monochrome card, showcasing a seasonal fashion line between the wars, was issued by the Co-operative Wholesale Society's advertising department. By the twentieth century, the northern end of Corporation Street had become the administrative centre of the Co-op, with banking, insurance and CWS buildings dominating the area. The CWS provided a range of goods for the retail shops in different Co-operative Societies. The card advertising the H. G. Mabbs range of electrical goods was from a 1913 postcard calendar, here showing the month of March. The card appears to be of American origin, with overprinted details for this Manchester business.

COP, '11, O. CO. N. Y. 902—GOOD COMPANY. BY JAMES ARTHUR.

H. G. MABBS

MARBLE STREET, SPRING GARDENS
MANCHESTER

Cables, Fans, Motor Starters, Pumps

Switches and Switchboards

Electrical Supplies of Every Description

1913	MARCH					1913
S	**M**	**T**	**W**	**T**	**F**	**S**
-	-	-	-	-	-	1
2	3	4	5	6	7	8
9	10	11	12	13	14	15
16	17	18	19	20	21	22
23 30 24 31	25	26	27	28	29	

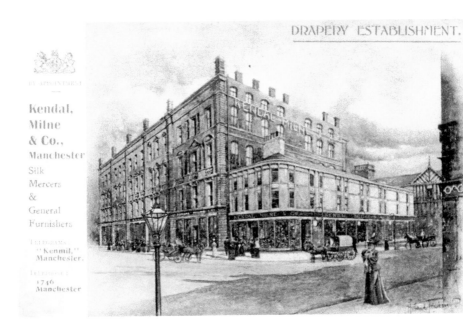

Kendal, Milne's Store and Greville's

This page illustrates advertising postcards from what were thought of as more fashionable retail outlets. Kendal, Milne & Co. (the comma is now usually omitted) was a long-established Manchester company. The origins go back to the eighteenth century when John Watts started a small drapery business. Then Messrs Kendal, Milne and Faulkner took over. On Faulkner's death in 1862, it became, Kendal, Milne & Co. Harrods purchased the store in 1919, and it was later acquired by House of Fraser. The card gives an artist's impression of the buildings on the east side of Deansgate, by King Street. The idea of 'carriage trade' is clearly suggested. St Ann's Square was also considered a shopping destination for the more affluent, as typified by the Edwardian card promoting autumn fashions.

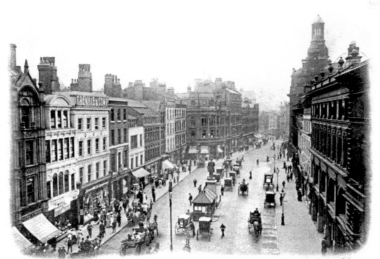

ST ANN'S SQUARE.
MANCHESTER.

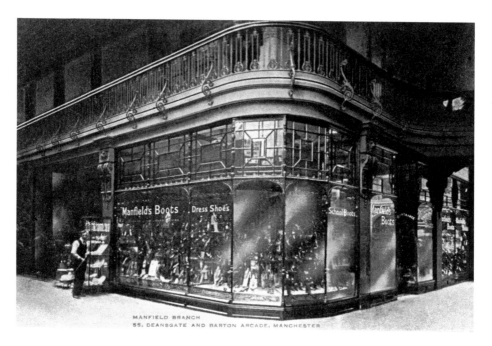

MANFIELD BRANCH
55, DEANSGATE AND BARTON ARCADE, MANCHESTER

Barton Arcade and Paulden's

Clare Hartwell, in the Manchester volume of the *Pevsner Architectural Guides* series, describes the Barton Arcade as 'probably the best example of this type of cast-iron and glass-roofed arcade anywhere in the country'. It was included in new buildings put up following an Act of 1869 to improve Deansgate. The sepia postcard advertises Manfield & Sons, a Barton Arcade bootmaker. Paulden's was a department store on Cavendish Street, Chorlton-on-Medlock. The reverse side of this Edwardian advertising card sketches the store building in its street setting. It is from a set of similar Paulden's postcards, the fronts depicting different Manchester views. The Cavendish Street store was gutted by fire in 1957, and Paulden's moved to the Rylands building on Market Street.

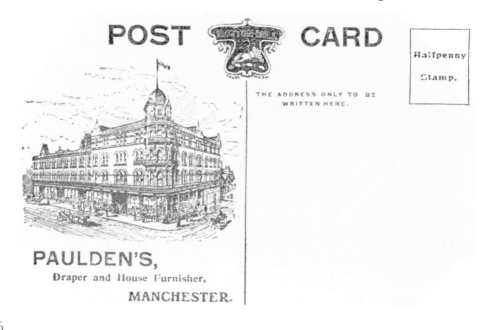

POST CARD

Halfpenny Stamp.

THE ADDRESS ONLY TO BE WRITTEN HERE.

PAULDEN'S,
Draper and House Furnisher,
MANCHESTER.

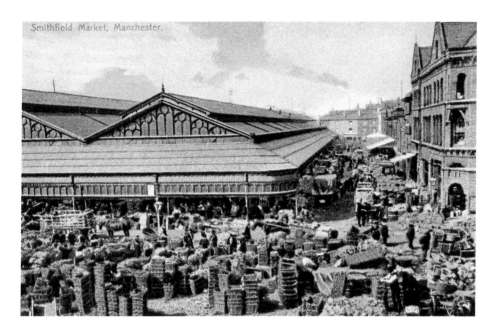

Smithfield Market

The top postcard, mailed in 1909, gives some idea of the seemingly chaotic activity that took place around the vast expanse of Smithfield Market. The market and associated buildings, contained by the angle of Shudehill and Swan Street, spread over several acres. In 1822, the market was open to the skies, but had been glazed over by the 1850s. A Manchester Markets Act of 1846, had enabled the Corporation to provide and regulate local markets. There was wholesale trade in fruit, vegetables and flowers, but also retail and wholesale business in fish. The sepia postcard, from the 1920s, shows a view from High Street. The Wholesale Fish Market, which formally opened in 1873, is on the left. In the distance is an entrance to the Smithfield fruit and vegetable market.

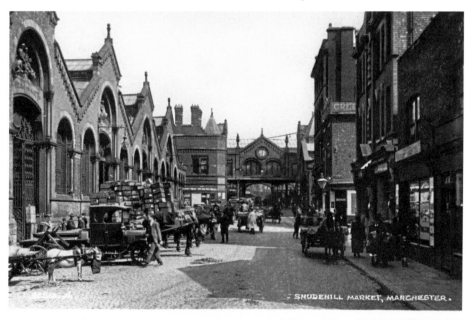

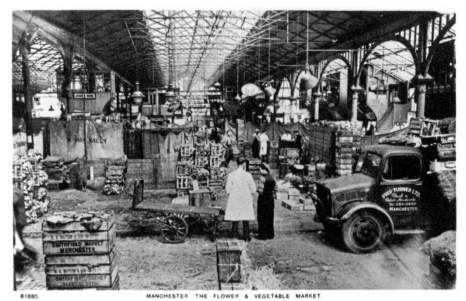

61680. MANCHESTER. THE FLOWER & VEGETABLE MARKET.

Smithfield Market

The monochrome real photographic postcard was published after the Second World War, possibly by the early 1950s. It gives some idea of the boxes, crates and clutter that the traders and porters worked amid. The lorry on the right is identified as belonging to 'Fred Turner Ltd, Fruit & Potato Merchant'. It has been claimed that Smithfield Market was the single biggest employer of those from Irish families living in nearby Ancoats, whether as stallholders, porters or labourers. The Edwardian coloured postcard was issued by Raphael Tuck in their painterly oilette style. Buyer and seller are brushstroked among the vegetables in 'Shudehill Market, Manchester'. The market had closed by 1972, moving to Openshaw, where it was ceremonially opened in 1974.

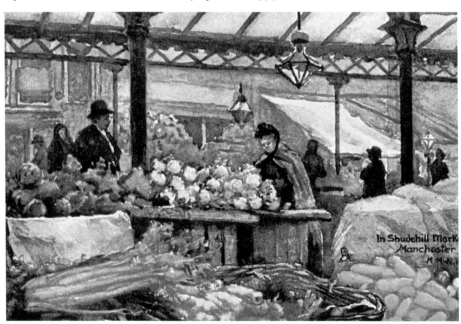

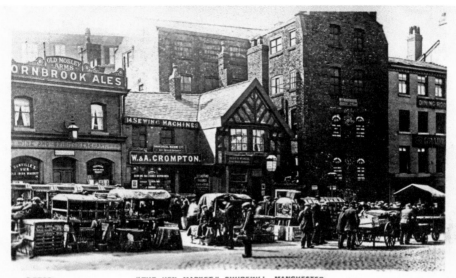

S.2552 "THE HEN MARKET," SHUDEHILL, MANCHESTER.

Shudehill Street Market and Corn Exchange

The postcard showing the kerb stalls on Shudehill is from the 1920s. It is captioned as the 'Hen Market', and the makeshift-looking cages made Shudehill 'famous for its poultry and pets market and cheapjacks'. It was also possible to browse the second-hand book stalls. In the background are buildings all gone. The gable end of the ancient Rover's Return, demolished in the 1950s, is seen to the right of the 'Crompton' sign. On the left of the image is the Old Mosley Arms pub, which survived into the 1970s, when the Arndale development swept much away. The coloured Corn Exchange card dates from about 1905, when the building's two-phase construction of 1893 and 1903, had not long been completed. The curved front follows the arc of a medieval watercourse called Hanging Ditch, which is now the street name.

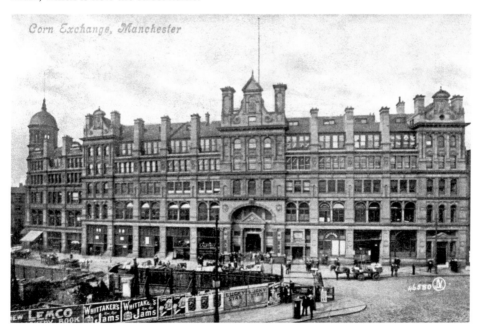

Corn Exchange, Manchester

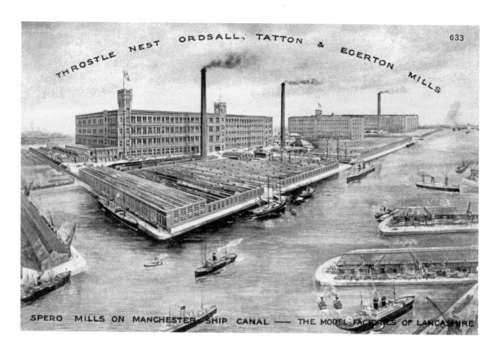

THROSTLE NEST ORDSALL, TATTON & EGERTON MILLS

SPERO MILLS ON MANCHESTER SHIP CANAL — THE MODEL FACTORIES OF LANCASHIRE

Richard Haworth & Co., Cotton Mills

Manchester gained the moniker 'Cottonopolis' due the rapid increase of textile production centred on the city. This wasn't Manchester's only occupation. Mancunians worked in engineering, chemicals, foodstuffs, retailing, banking, insurance and other sectors. Cotton spinning and weaving, though, came to characterise the city in the popular imagination. In the early nineteenth century there were mills in the central areas, although after mid-century the textile warehouse came to dominate the street scene. There was also, of course, the Royal Exchange, the nucleus of cotton trading. Production itself moved further out. Both cards on this page serve to advertise one cotton manufacturer. Richard Haworth & Co. were large-scale spinners and weavers, with mills in the Ordsall district of Salford. They did, though, have a central Manchester warehouse, which was located on Dale Street.

SECTION 7

TRANSPORT

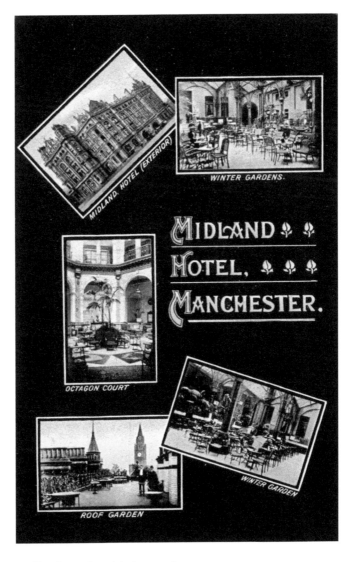

Midland Hotel multi-view card.

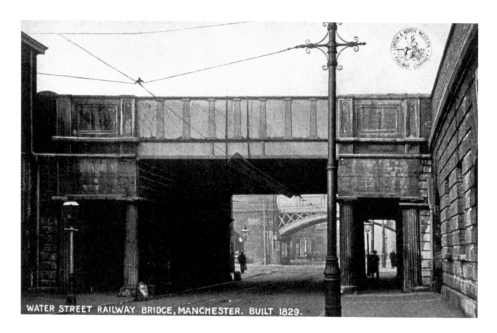

WATER STREET RAILWAY BRIDGE, MANCHESTER. BUILT 1829.

Water Street Bridge and Exchange Station

Edwardian railway companies produced sets of postcards related to their particular routes. These cards, because they were published by the railways themselves, are now sometimes known as 'official' postcards. The London & North Western Railway issued the upper card in January 1905. It features the original Water Street Bridge, built for the 1830 Liverpool & Manchester Railway (later part of the LNWR). The bridge was demolished in 1904 for a replacement, so even by 1905 the card was documenting history. Exchange station, actually on the Salford side of the River Irwell, was built for the LNWR and opened in 1884. Prior to this the company's trains had been using Victoria's platforms. Exchange, which suffered bomb damage in 1940, closed in 1969.

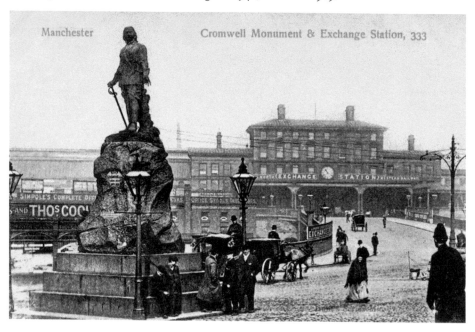

Manchester　　　　　Cromwell Monument & Exchange Station, 333

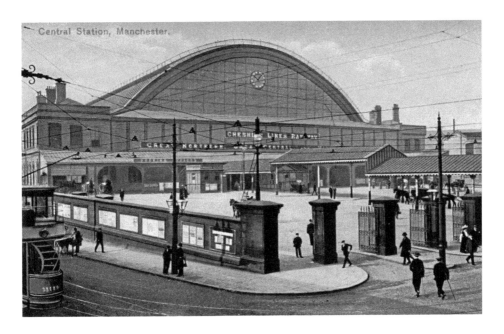

Central Station and Midland Hotel

The arched roof of Central station made it a photogenic building for postcard publishers, although the station never had the architectural impact of other city stations such as London Road, Exchange or Victoria. These had noteworthy office buildings in front of their train sheds, something lacking here. This station had opened in 1880, and by the 1900s was home to the Cheshire Lines Railway, a grouping of the Great Central, Great Northern and Midland companies. Despite missing a grand booking hall and office building, Central did have the Midland Hotel, which opened in 1903 just across the street. It was built as a luxury railway hotel. The postcard on this page was published by the Midland Railway Hotels group about the time of the opening. It is from a set of artist-created scenes, showing the inside and exterior of Manchester's eye-catching new landmark.

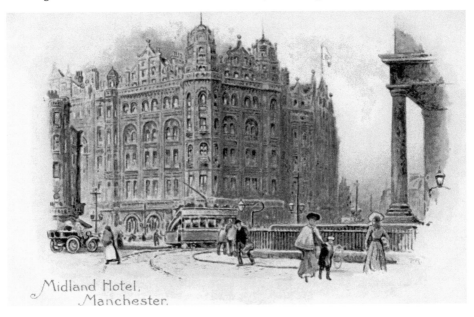

Midland Hotel, Manchester.

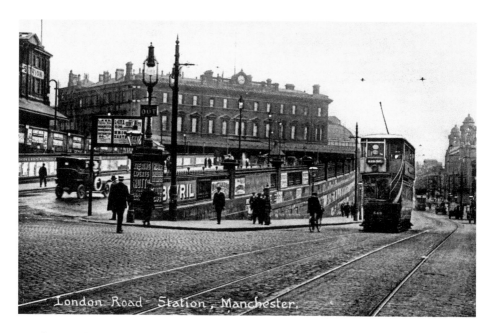

London Road Station (later Piccadilly)

This station was built on a viaduct above London Road and opened in 1842. Railway companies of the 1840s – such as the Manchester & Birmingham, Liverpool & Manchester and the so-called Grand Junction – were incorporated into the giant London & North Western Railway. This company worked its trains into London Road, where it shared the station with another operator, which by the Edwardian age was called the Great Central Railway. The LNWR ran trains to London Euston, emphasising speed, while the Great Central worked into London Marylebone, and stressed comfort and scenic beauty. The postcard below shows the king and queen's departure from London Road on 14 July 1913. They had just completed a tour of Lancashire, culminating in a state visit to Manchester.

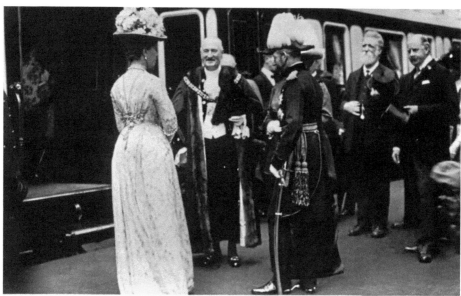

9495 V THE ROYAL TOUR IN LANCASHIRE ROTARY PHOTO. E.C.
THEIR MAJESTIES LEAVING FOR LONDON (LONDON ROAD STATION). THE LORD MAYOR BIDS GOOD-BYE TO THE KING & QUEEN.

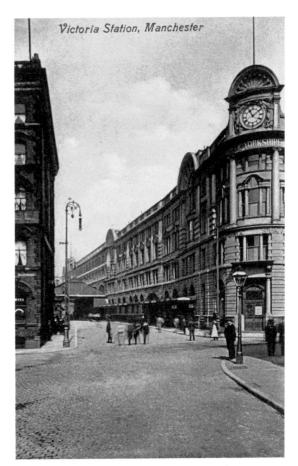

Victoria Station, Manchester

Victoria Station

Like London Road station, Victoria dates from the 1840s, a decade sometimes known as the age of the 'railway mania'. It was opened in 1844 and served trains of both the Liverpool & Manchester and the Manchester & Leeds railways. In 1884, Victoria was greatly increased in size and the neighbouring Exchange station also opened. Victoria became one of the largest stations in the country, and in Edwardian times was the administrative centre of the Lancashire & Yorkshire Railway (in which the M&L had become absorbed). The street view, from a postcard mailed in 1912, shows the then recently completed frontage of 1909, by local architect William Dawes. The platform scene is on the site of the Manchester Arena.

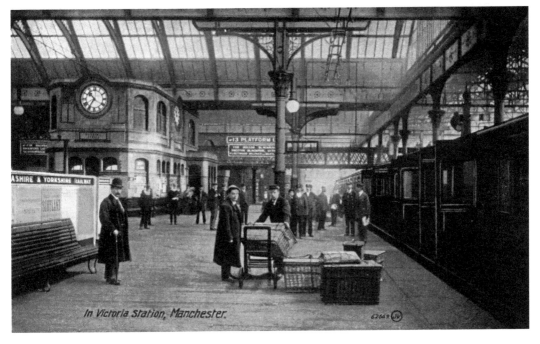

In Victoria Station, Manchester.

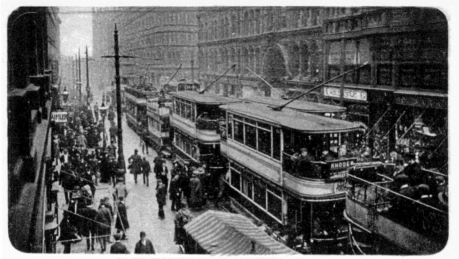

DEANSGATE LOOKING TOWARDS MANCHESTER CATHEDRAL.

Trams on Deansgate

Postcards from the early decades of the twentieth century, if they feature Manchester's main streets, will probably include trams. The first trams, dating from 1877, were horse-drawn and operated by a private company. The Corporation, however, had laid the tracks and leased them. When the leases were due to expire, Manchester applied to run the system itself and also convert the traction to electric power. The first electric trams were inaugurated in June 1901. The two cards on this page are of contrasting design and finish, although they each show tram scenes on Deansgate. The sepia view, which shows trams of neighbouring Salford Corporation, is credited to James L. Brown of Ardwick, who specialised in real photographic street scenes.

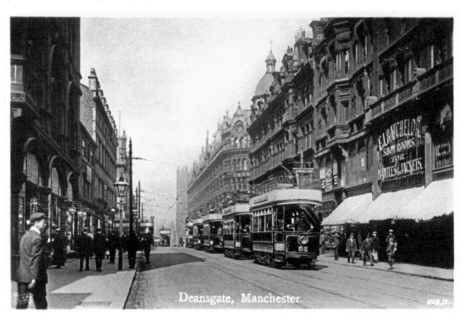

Deansgate, Manchester.

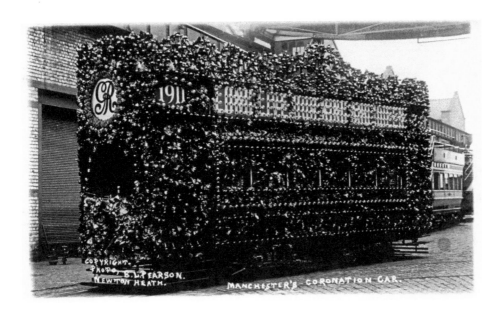

Corporation Tram and Parcel Van

On ceremonial occasions, the Corporation would smother a tram in lights and decorations. The one seen here was for the 1911 coronation. The postcard – an actual photograph – was by Berne Lancelot Pearson and produced at his studio on Oldham Road, Newton Heath. It would have been hand printed by the photographer or an assistant. Pearson, who lived at Ardwick, where his family ran a butcher's shop, was a self-employed photographer by the age of sixteen. The study of the van and driver from the city's Parcels Department is an image also from a real photographic postcard. The photographer is not given this time. In the 1930s, the Corporation offered a parcel delivery service. They would collect from stores and warehouses, and, for lighter items, the parcels could be handed to the conductor (or 'guard') of a Corporation tram.

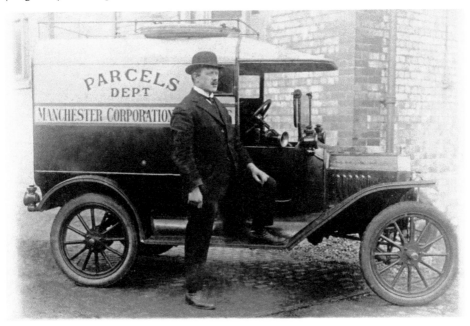

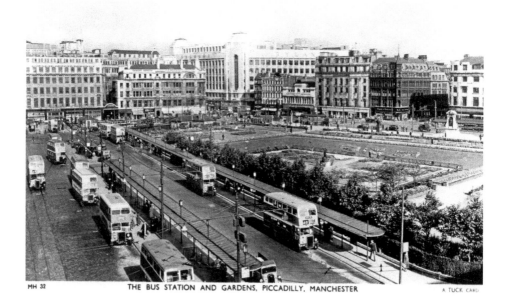

Parker Street Bus Station and Mancunian Way

The electric tram was to have a rival in the form of the motor bus. These buses were at first used in the suburban districts or as feeders to the tram system. However, during the 1930s, route conversion took place, with buses replacing certain tram routes. One of the reasons was the cost of tram track renewal. When motor buses came into the city centre, it was recognised that there was need for a bus station. In 1931, the first part of the Parker Street bus station was opened. It was completed four years later. The monochrome postcard shows the bus station in the 1950s, by which time tram services had ceased, with final abandonment in 1949 (until Metrolink, that is!). The coloured card, posted in 1973, features the Mancunian Way, an elevated inner-city motorway that was formally opened in 1967. (Mancunian Way postcard © John Hinde Archive)

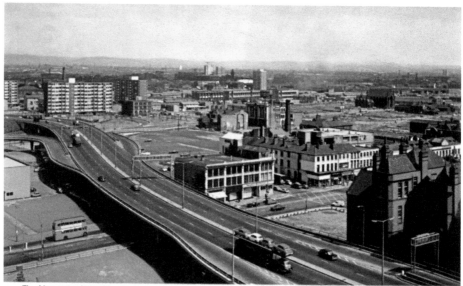

The Mancunian Way, Manchester

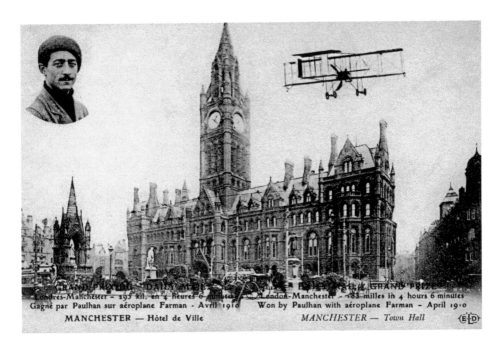

GRAND PRIX DU DAILY MAIL GRAND PRIZE
Londres-Manchester – 295 kil. en 4 heures 6 minutes London-Manchester – 183 milles in 4 hours 6 minutes
Gagné par Paulhan sur aéroplane Farman – Avril 1910 Won by Paulhan with aéroplane Farman – April 1910
MANCHESTER — Hôtel de Ville MANCHESTER — Town Hall

Aviation Challenge and Manchester Airport

The unusual postcard showing Manchester Town Hall, biplane and pilot portrait, was actually issued in France. It celebrates the winning of an aviation challenge made by the *Daily Mail* in 1906. The paper offered £10,000 for the first aviator to fly between London and Manchester in under twenty-four hours with no more than two stops. A Frenchman, Louis Paulhan, won the prize in April 1910, landing his plane at a field in Didsbury. More conventional air travel to and from Manchester centres on Manchester Airport, a major international flight hub for the north of England. It was originally called Ringway, and officially opened in 1938. The existing municipal aerodrome at Barton was limited in its ability to handle the then modern generation of aircraft. (Manchester Airport postcard © John Hinde Archive)

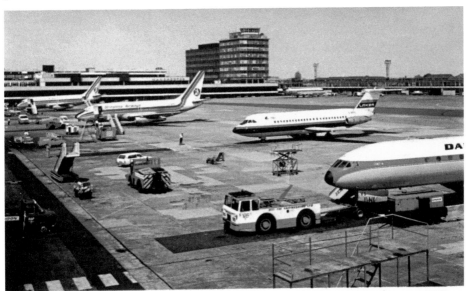

Manchester Airport

M.0257

SECTION 8

RECREATION

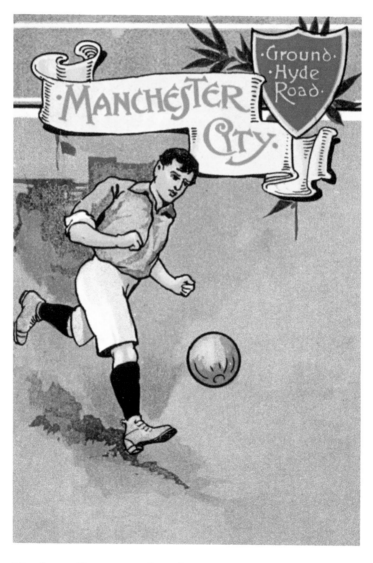

Manchester City poster-style card.

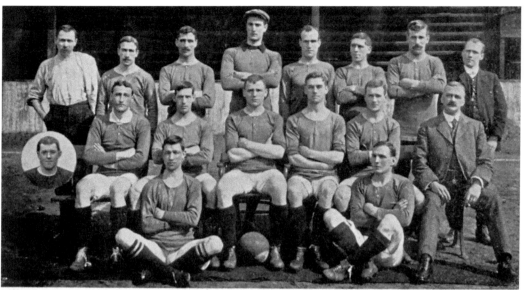

Photo by R. Scott & Co., Manchester. **MANCHESTER UNITED (Cup Team).**

F. Bacon, Tra. H. Halse W. Meredith H. Moger J. Picken G. Wall Stacey H. Burgess
A. Turnbull J. Turnbull R. Duckworth C. Roberts, Capt. A. Bell V. Hayes Mr. Mangnall, Sec.
G. Livingstone A. Downie

Manchester United and St James's Hall
The connection between a football team and the Oxford Street exhibition hall may not seem obvious. However, a fundraising bazaar was held at the St James's Hall in 1901 to help the Newton Heath football club, which was in financial difficulties. A St Bernard dog escaped from the bazaar and found its way to a brewer, John Henry Davies, who eventually helped rescue to club. The following year, the club's name was changed to Manchester United. The postcard of the hall was mailed in 1904. The Manchester United card was issued for the FA Cup final of 1909. They beat Bristol City in the final, then played at the Crystal Palace in south London. This was the club's first success in this competition. The card was published by Robert Scott, who lived at Chorlton-on-Medlock. His output included other sports, and from places beyond Manchester.

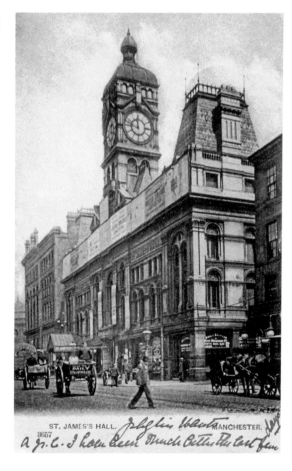

ST. JAMES'S HALL. MANCHESTER.

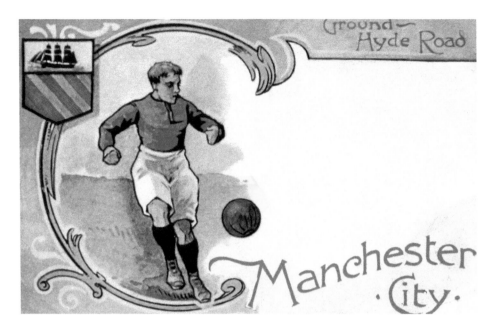

Manchester City and Racecourse Grandstand

The Manchester City football postcard was mailed in 1907. It is one of a set of similar cards featuring different clubs. City's then home ground is named as Hyde Road, where they played until the move to Maine Road in 1923. In Edwardian times City had success when they won the FA Cup in 1904, but they also suffered relegation from the First Division in 1902 and 1909. The sepia card of the racecourse grandstand was produced by James Brown of Ardwick, the publisher of many Manchester scenes in the 1920s. The racecourse at this time was called Castle Irwell, located not in Manchester but Salford. Prior to this, the 'Manchester' races were run at New Barnes, Weaste, also in Salford. This earlier racecourse had been acquired in 1902 by the Manchester Ship Canal Co. Racing at Castle Irwell continued until 1963.

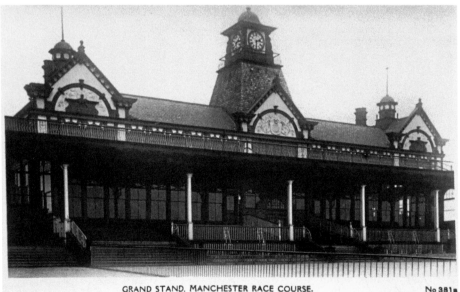

GRAND STAND, MANCHESTER RACE COURSE. No 381a

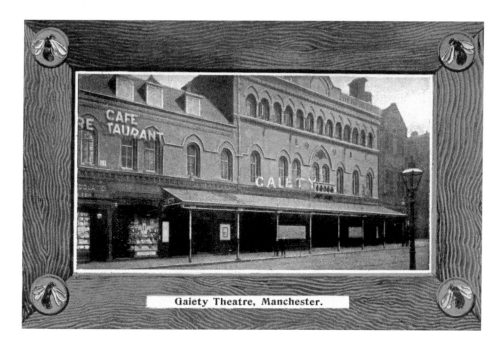

Gaiety Theatre, Manchester.

Gaiety Theatre and Ardwick Empire

The Gaiety Theatre, originally known as the Comedy, stood on Peter Street. This Edwardian postcard was issued by a Manchester publisher based on Oxford Street – its continuation. The green framing effect includes four bees, symbols of Manchester's industry. The theatre was acquired in 1908 by Annie Horniman of the tea family, and she introduced repertory drama to the city. A so-called Manchester school of playwrights emerged, which included writers such as Harold Brighouse and Stanley Houghton. Across town in Ardwick, the Empire had opened in 1904, the same year as the Hippodrome on Oxford Street. Both were built for one of the UK's major impresarios, Oswald Stoll. The Gaiety was demolished in 1959. The Ardwick Empire, renamed the Hippodrome, closed in 1961.

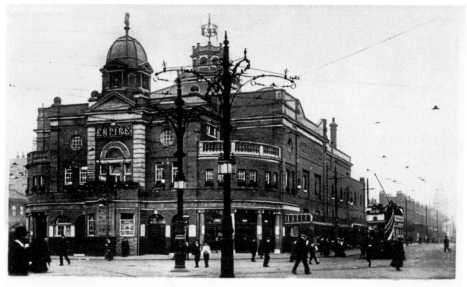

ARDWICK EMPIRE, MANCHESTER

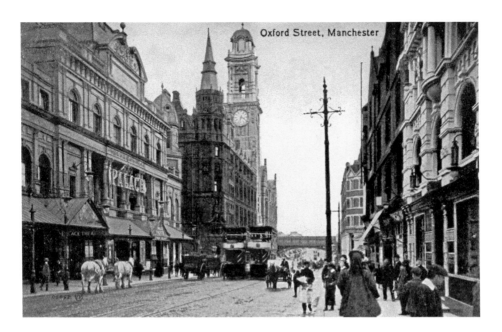

Oxford Street, Manchester

Palace Theatre and Gaumont Cinema

Oxford Street and Peter Street, together almost a single roadway, played host to a number of theatre, cinema and other entertainments. The Palace Theatre, seen on the left in the coloured postcard, had opened in 1891. On the same side was the St James's Hall, which included a theatre. The Hippodrome and Prince's Theatres were on the opposite side. On Peter Street were found the Free Trade Hall, Theatre Royal and Gaiety Theatre. In the 1930s, live shows were under threat from the new talking films. The Hippodrome was closed and the building demolished, to be replaced in 1935 by a modern luxury cinema, the Gaumont. This is seen on the left in the sepia postcard, where 'Road' should be 'Street'. Nearly opposite was another grand cinema, the Paramount, which opened in 1930 and was later called the Odeon.

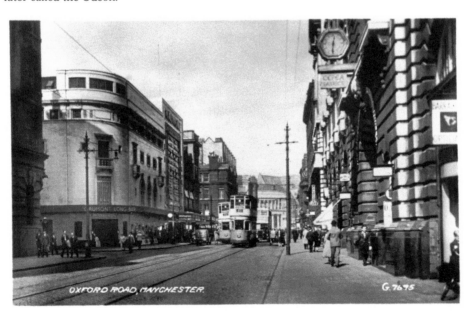

OXFORD ROAD, MANCHESTER. G.7675

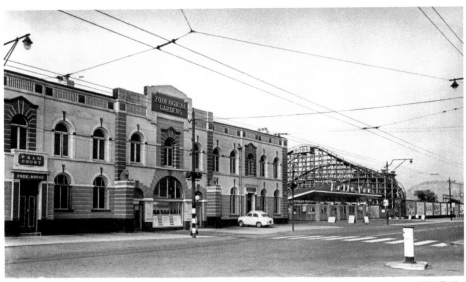

MAIN ENTRANCE
Zoological Gardens, Belle Vue, Manchester

Belle Vue

No account of recreation in Manchester could omit the Belle Vue Zoological Gardens, although it became far more than just gardens and a zoo. The origin goes back to 1836, when John Jennison took a lease on the site. It was built up over the next century and more, into probably the most varied entertainment complex in the north of England. A Manchester guide from the early 1930s gives the area as 64 acres. A guide from the 1940s calls it an 'eighty-acre entertainment centre' with 8 million visitors a year. The two postcards on this page show different entrances. The real photograph monochrome card, possibly from the 1950s, shows the main entrance on Hyde Road. Beyond the buildings is the Bobs rollercoaster, described as the 'most daring "coaster" outside America'. The coloured Edwardian card is of the Longsight entrance.

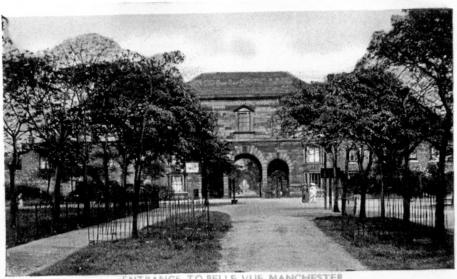

ENTRANCE TO BELLE VUE, MANCHESTER

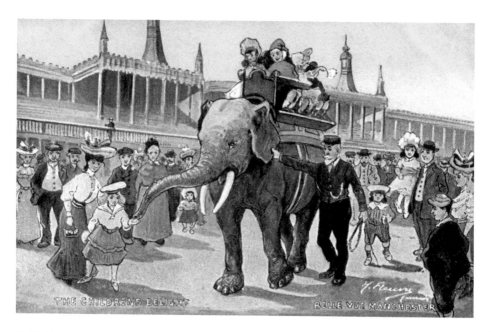

THE CHILDRENS DELIGHT BELLE VUE MANCHESTER

Belle Vue

The two pre-First World War postcards on this page – each in its own artistic style – suggest a couple of the many entertainments on offer at Belle Vue. The elegance of ballroom dancing by the refined classes is contrasted with the bank holiday fun and excitement of an elephant ride. During its history, Belle Vue brought visitors to experience firework displays, brass band competitions, rugby, speedway, dog racing, boxing, wrestling, boating on the lake, circuses, zoo animals and funfair rides. The Kings Hall was home to the Hallé Orchestra when the Free Trade Hall was bombed during the Second World War. The end began when the zoo closed in 1977. This was followed over the following years by the closure of other amenities.

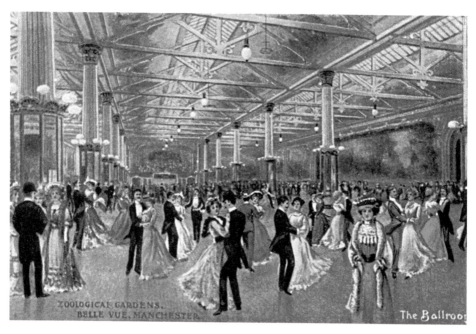

ZOOLOGICAL GARDENS. BELLE VUE, MANCHESTER. The Ballroom

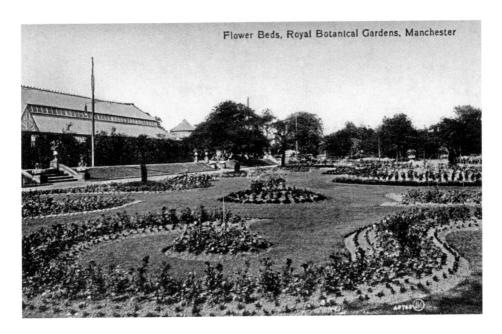

Flower Beds, Royal Botanical Gardens, Manchester

Botanical Gardens

By the time these two Edwardian postcards had been published, the Botanical Gardens, with an imposing entrance on Chester Road, Old Trafford, were in their final few years. The Manchester Botanical and Horticultural Society had been founded in 1827, following a meeting at the old Town Hall in King Street. For the gardens, scientist John Dalton suggested Old Trafford as a location free from the pollution of the industrial city. This he judged on the basis of the prevailing winds. Land was conveyed by the de Trafford family in 1829, and leased to the society. Plant houses and conservatories were erected and lawns laid out. In 1857, the grounds were used for the major Art Treasures' Exhibition, when a huge iron-and-glass main hall was built. However, by the new century, subscription income had fallen, and part of the site was used for the White City amusement park.

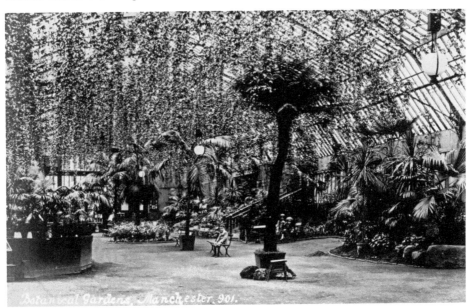

Botanical Gardens, Manchester. 901.

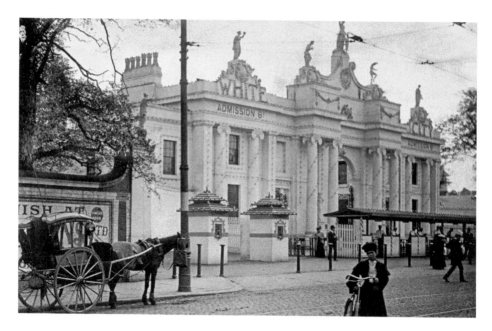

White City

The postcard of the White City's grand entrance on Chester Road was mailed in 1907, the same year that this new amusement park was opened by Heathcote & Brown. The operators had created the fun park in just ten weeks. This entry point, with its classical features and Ionic columns, was built for the refined subscribers of the Botanical Gardens. The White City proprietors also wished to keep up the social tone. Nothing 'in the least way objectionable to the educated or refined taste' was permitted in the grounds. They declared it was to be a 'pleasure garden of the highest class'. The entertainments included the Figure-8 coaster ride seen here, along with a water chute and helter-skelter. There was also a photographic studio for the printing of pictures that froze visitors against a background of their choice – Edwardian selfies! The White City Stadium was later built on the site, then a retail park.

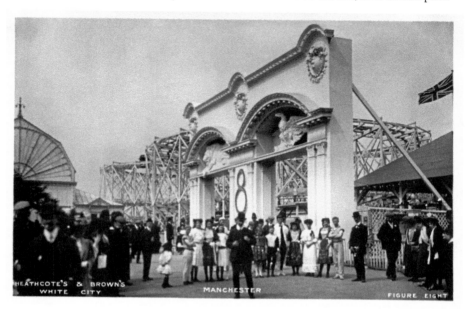

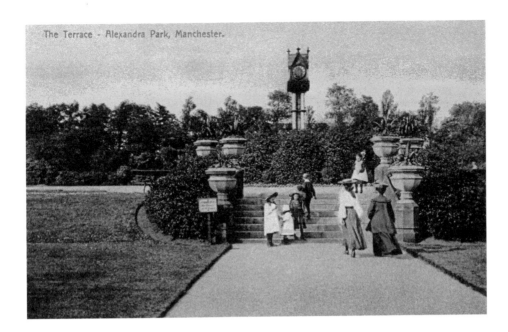

The Terrace - Alexandra Park, Manchester.

Parks

Here are just two examples of the many postcards that depicted Manchester's parks. In 1915, a handbook of the city's parks and recreation grounds asserted that they 'brighten life in narrow streets and in a damp and smoke-laden atmosphere'. This was also in the minds of those who, more than seventy years earlier, had raised subscriptions for two parks in Manchester and one in Salford. On the same day in 1846, Queen's Park in Harpurhey, Philips Park, Bradford, and Peel Park, Salford, were ceremonially opened. Laid out by voluntary means, they were then conveyed to the local Corporations. Future additions added to the Manchester parks' estate. Whitworth Park is one of the city's memorials to the Victorian engineer and benefactor, Joseph Whitworth. Opened in 1890, it was leased to the Corporation in 1904 by Whitworth's trustees. Alexandra Park dates from 1868.

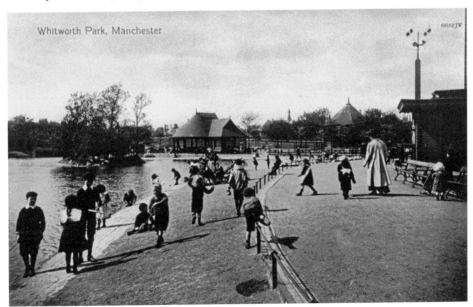

Whitworth Park, Manchester

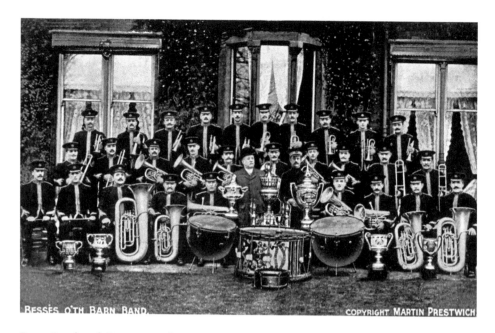

BESSES O'TH BARN BAND. COPYRIGHT MARTIN PRESTWICH

Brass Band and Crown Hotel

These two postcards are of subjects each recreational in its own way. Besses o'th Barn brass band members, here photographed in Edwardian times with trophy next to trophy, are lined on up on a postcard credited to a local Prestwich publisher. The band claims a history at least as far back as 1818. In 1903, they won the brass band national championship at the Crystal Palace in London. Following on from this, the band toured not only in this country but overseas as well. The street view of the Crown Hotel is by Arthur Harold Clarke, a Manchester photographer and postcard publisher active in the 1930s. This city centre pub stood on the corner of Booth Street and Fountain Street. The building seen here was demolished in 1962.

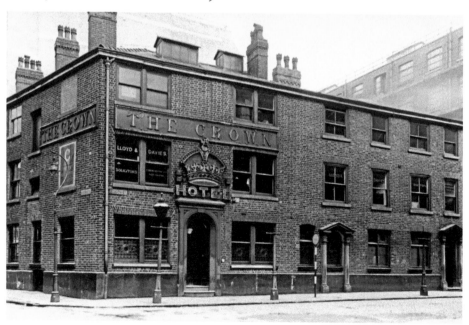

SECTION 9

AWAY FROM THE CITY CENTRE

Royal Infirmary and university.

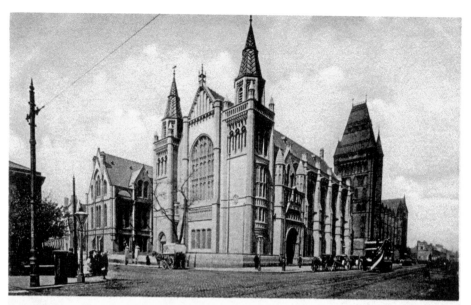

Victoria University. *Manchester.*

A. Megson & Son, Stationers, Manchester

Whitworth Hall and Physics Group, University of Manchester

The university, when still Owens College, had moved to Oxford Road in the 1870s. In 1902, the Whitworth Hall was opened. The University of Manchester gained an international reputation for physics in the early twentieth century. The photographic postcard of physics staff and students was made by Edward Vincent Ward, who had a studio on Oxford Road, near the university. His late father, also an Edward Ward, sold microscopes and slides from the same premises. In the centre of the group is Professor Ernest Rutherford, who suggested the nuclear model of the atom. To his left sits Arthur Schuster, his predecessor as professor of physics. Hans Geiger is on the left end of the same row. Henry Moseley, second left on the front row, worked out a breakthrough X-ray law. He died in the First World War. At the right end of the front row is James Chadwick, who later discovered the neutron.

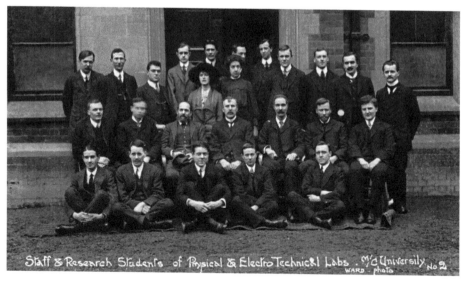

Staff & Research Students of Physical & ElectroTechnical Labs. M'c University No 2

WARD · photo

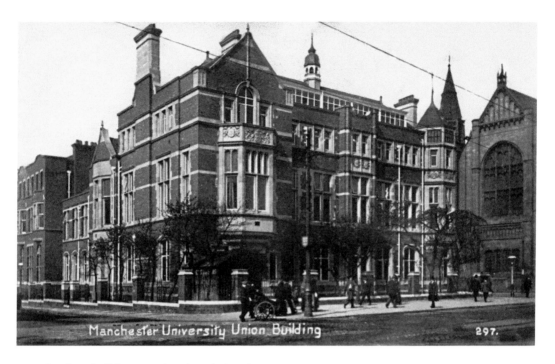

Manchester University Union Building 297.

Student Buildings, University of Manchester

The two postcards seen on this page were produced possibly fifty years apart. Both show the Oxford Road setting of buildings put up for students' non-academic needs. The sepia view is a real photographic image of the student union building that was demolished in the 1950s. The gable end of the Whitworth Hall is on the right, adjacent to the union building. Until the 1950s the men's and women's student unions were separate organisations. A new union building was designed that decade by John Somerville Beaumont, also architect for the Kendal Milne store, and built off frame to the left. The coloured postcard shows the refectory that replaced the old union building.

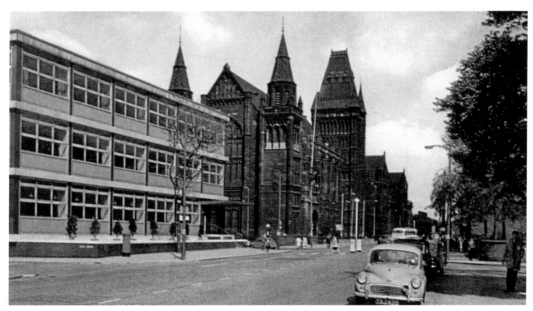

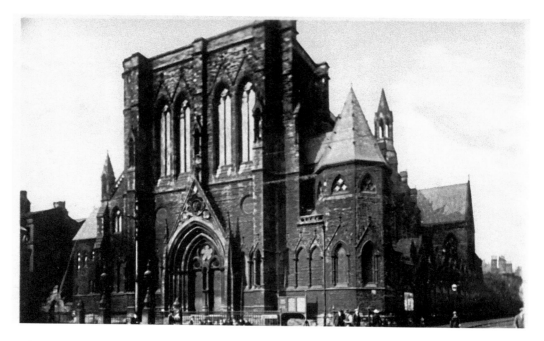

Holy Name Church and Oxford Road

Chorlton-on-Medlock was one of the original townships that comprised the municipal borough of Manchester on its incorporation in 1838. Oxford Road is the main route through the district. Both postcards on this page were published by James L. Brown of Ardwick, and are typical of his real photographic topographical cards. That of the Church of the Holy Name was posted from Manchester to Sweden in 1925. This Roman Catholic church was built by 1871 and staffed by Jesuit priests. A tower was added in 1928, not long after the postcard photograph was taken. The Oxford Road street scene shows the Royal Eye Hospital on the left, with the Royal Infirmary seen further along. Beyond is yet another hospital, St Mary's.

VIEW OF OXFORD ROAD, MANCHESTER

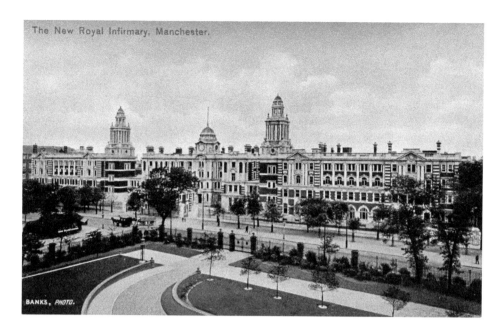

The New Royal Infirmary, Manchester.

BANKS, PHOTO.

Royal Infirmary and Blind Asylum

The postcard of the 'New' Royal Infirmary on Oxford Road was published by Philip G. Hunt, giving a London business address. He also worked from Deansgate, advertising himself as a 'Pictorial Postcard Printer', and as an agent for German printers. The infirmary card was colour printed in Hessen, using an original image by Robert Banks, the Manchester photographer. The Royal Infirmary had moved from Piccadilly in 1908 and was ceremonially opened the following year. The Blind Asylum was built in 1837, next to the Botanical Gardens at Old Trafford. There was also an adjoining school for the deaf and people with additional needs. The architect was the Manchester-based Richard Lane. The Blind Institution was part of Henshaw's charity, which still exists. It is named after Thomas Henshaw, a wealthy Oldham hat manufacturer who died in 1810 leaving a bequest. The building seen here was demolished in the 1970s.

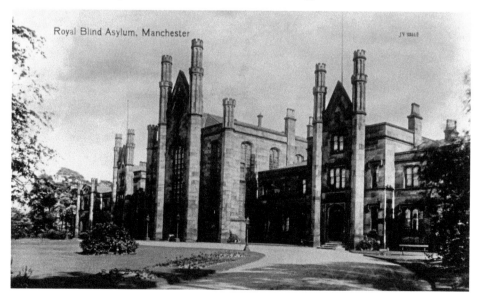

Royal Blind Asylum, Manchester

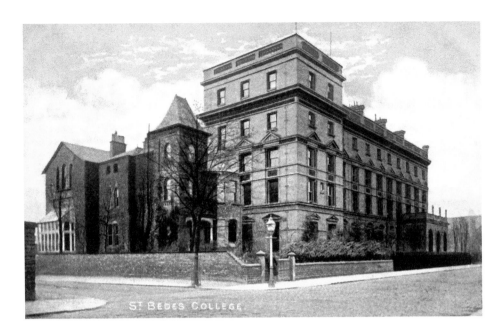

St Bede's College and Burnage Garden Village

The postcards on this page are of two scenes in districts to the south of the city centre. The Edwardian card of St Bede's College features the Vaughan building on Alexandra Road South, in Whalley Range. The college had been established in 1876 by the Roman Catholic Bishop of Salford, Herbert Vaughan. At first it was housed on Grosvenor Square, Oxford Road, before removal to the present site, where this building was subsequently erected facing Alexandra Park. The sepia card, which was posted in 1913, shows housing in the Garden Village at Burnage. This development was part of a wider movement in the early twentieth century to create healthier living conditions. Its best known example was Letchworth Garden City in Hertfordshire. This was an entirely new town, but on a lesser scale were garden suburbs and the Garden Village in this Manchester suburb.

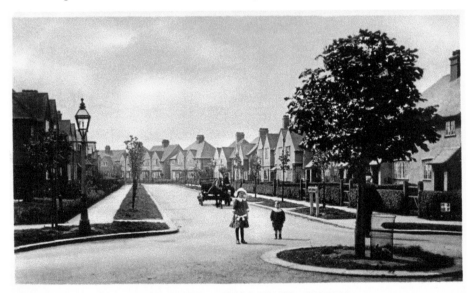

21837 NORTH AVENUE, GARDEN VILLAGE, BURNAGE.

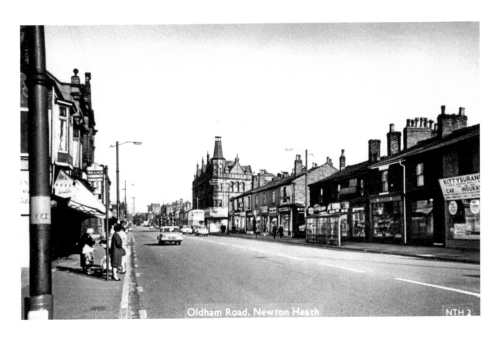

Oldham Road, Newton Heath NTH 2

Newton Heath and Brooks Bar

The stretch of Oldham Road, Newton Heath, shown in the top postcard, exemplifies a comment written in 1915 by a reporter from the *Manchester Guardian.* He was describing the seemingly endless spread of urban Manchester beyond its municipal borders. 'From Manchester to Oldham', he wrote, 'it is one street, and very nearly one row or one terrace'. This scene is from maybe fifty years later, but the point remains. The line of individual shops on the right was cleared for modern housing. The border with Failsworth is in the distance, past the taller building, which survived the demolitions. The view of the Whalley Hotel at Brooks Bar is from the 1920s. It is on another street postcard issued by James Brown. Whalley Range had been laid out in the 1830s by a wealthy banker, Samuel Brooks, as an exclusive residential development.

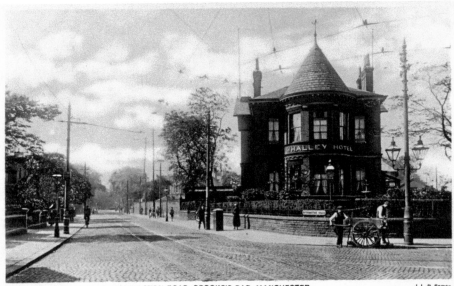

84A WITHINGTON ROAD, BROOKS'S BAR, MANCHESTER J. L. B. SERIES

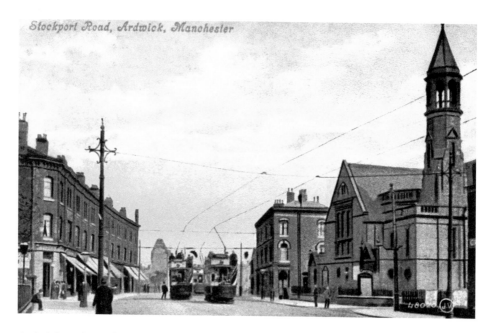

Ardwick and Stretford

Ardwick had been one of the earliest retreats from the crowded streets of central Manchester. However, by the twentieth century, it had been built up with workers' housing. The Empire variety theatre was opened in 1904. There were railways and trams passed down the main thoroughfares of Hyde Road and Stockport Road. The postcard, mailed in 1909, is based on a photograph taken near the junction with Devonshire Street, on the left. The so-called Octagon congregational church is opposite, on the right. Stretford, seen here in Edwardian times, was never administratively within Manchester's city borders, but is closely linked. The Trafford Park industrial estate was established here, and both Manchester United and Lancashire County Cricket Club have their home grounds in Stretford. The public hall with its clock tower was built at the expense of John Rylands, the textile magnate, who lived in Stretford.

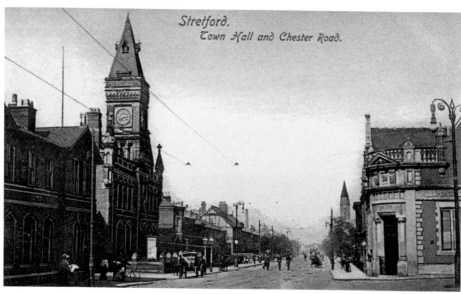

Stretford.
Town Hall and Chester Road.

SECTION 10
SHIP CANAL AND DOCKS

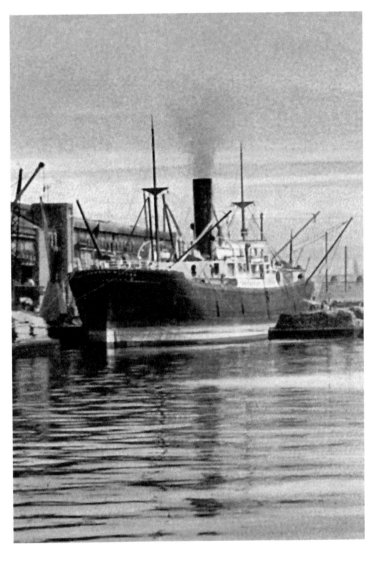

Salford Docks.

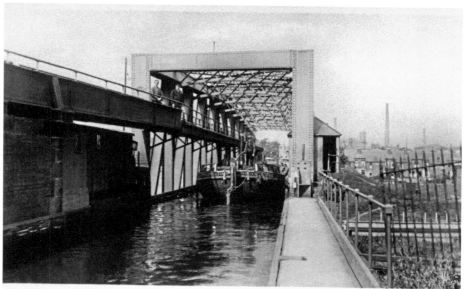

512

MANCHESTER SHIP CANAL.
BARTON AQUEDUCT IN POSITION TO ALLOW TRAFFIC TO PASS ALONG THE BRIDGEWATER CANAL
OVER THE SHIP CANAL.

Barton Aqueduct

Even before the Ship Canal was conceived, two earlier waterway schemes had brought vessels into Manchester. First was the Mersey & Irwell Navigation, which had modified the two existing rivers and was operating by the 1730s. The modern Quay Street in the city centre is a reminder that there were once wharves by the Irwell. Better known is the Bridgewater Canal, which had reached the Castlefield Basin in 1764. One of the wonders of this newly cut water channel was the aqueduct at Barton, which was ready by 1761. A stone bridge carried the Bridgewater Canal over the River Irwell. When the Manchester Ship Canal was constructed, a new Barton Aqueduct replaced the Georgian version. It was essentially an elongated water tank that could be sealed at both ends, and swung round to allow Ship Canal vessels to pass. The sepia view is from the 1920s.

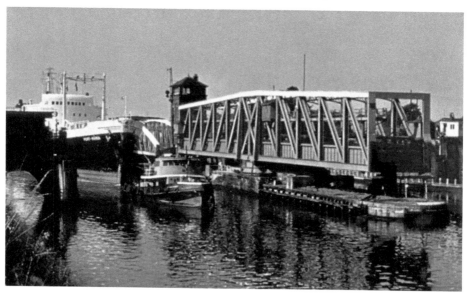

90

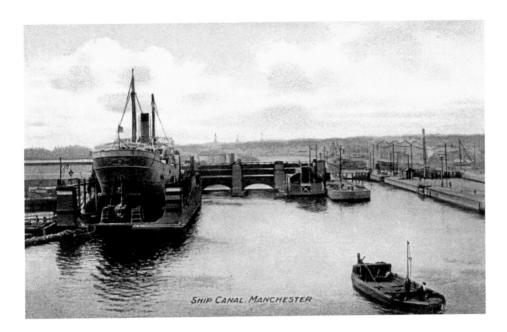

SHIP CANAL, MANCHESTER

Mode Wheel

Although there had been suggestions of a fully tidal ship canal, this would have meant deep excavations near the docks, as Manchester is 60 feet or so above sea level. The plans implemented, though, involved a series of locks along its 35 miles of length. The furthest locks from the Mersey Estuary were at Mode Wheel. As well as the locks, there were three dry docks nearby for ship repair work. In addition to these fixed graving docks, was a floating pontoon dry dock. This is seen in the top postcard, where a ship is undergoing repairs or an inspection. This card also gives an idea of the Mode Wheel Locks. The other card, which is artist-interpreted, is titled: 'The Manchester Ship Canal from Mode Wheel Dry Dock - Rain'. The tower-like structure in the middle distance is a grain elevator.

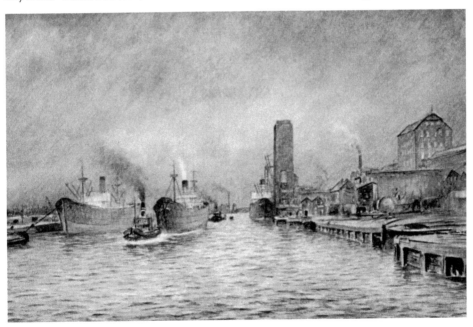

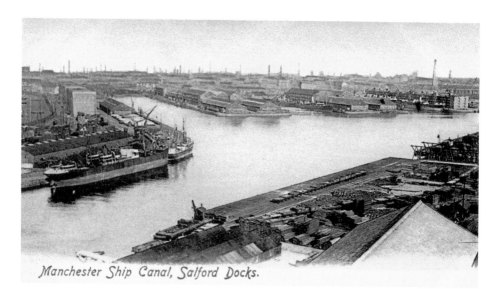

Manchester Ship Canal, Salford Docks.

Docks Overview

These two postcards offer similar, but time-lapsed, views. The docks area of the Manchester Ship Canal was not within the City of Manchester borders, except for part of one of the smaller docks. The large docks, for oceangoing ships, were in Salford, and the small docks, intended for coastal vessels, were mostly in Stretford. The docks were not given names but numbers. These ranged from Dock No. 1 to Dock No. 9. However, there were only eight docks, because No. 5, though planned, was never finished and operational. The coloured postcard from around 1903 shows a section of the old racecourse near the left edge. No. 9 Dock, which was constructed on part of the racecourse site, had not yet been excavated. The later, sepia card gives a good idea of the railways that were part of the dock system. The timber stacked up in the foreground is on Trafford Wharf in Stretford. In the middle distance are three of the Salford docks. The racecourse site has been transformed into a railway marshalling yard.

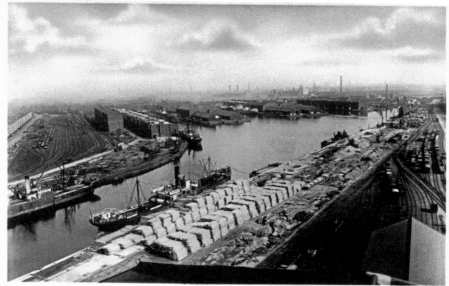

Nos. 6, 7, & 8 Docks, Trafford Wharf, Manchester. P9.

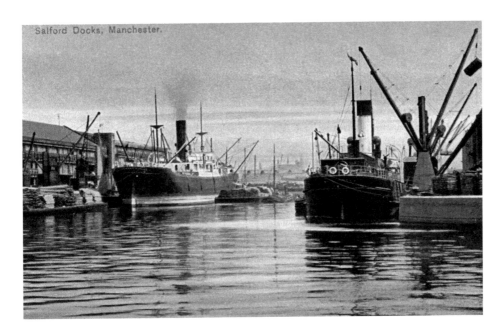

Salford Docks, Manchester.

Dock Scenes

These two Edwardian postcards were issued when the opening of the Manchester Ship Canal and its dock system in 1894, and the earlier difficulties – both political and engineering – were within easy recall of adult Mancunians. There had been a trade slump and Manchester was in economic decline. The idea of the canal was to counter the dock charges of the Port of Liverpool and the transport costs of the railway companies. It met with predictable opposition from these two quarters, but there were also other doubters. A meeting in 1882 at the Didsbury home of Daniel Adamson, an engineering manufacturer, was to be a key step in making Manchester – 35 miles from the sea – a port city. The docks at the head of the Ship Canal enabled Manchester and its region to import and export directly from and to the world.

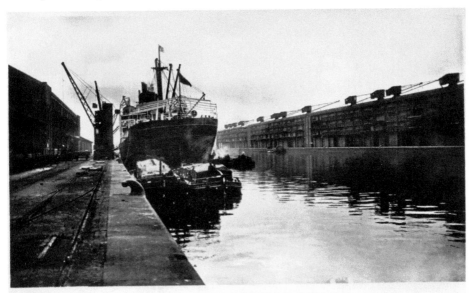

S 6649 LOADING IN NO 8 DOCK, MANCHESTER SHIP CANAL.

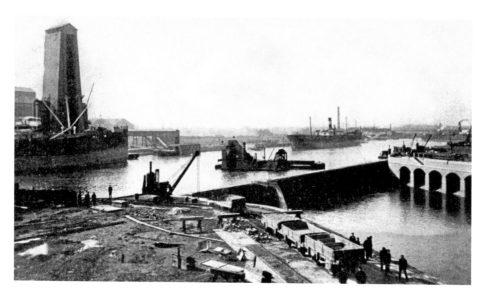

Dock No. 9

Although trade through the docks was at first disappointing, a decade after opening the Ship Canal had made Manchester the fifth United Kingdom port, based on the value of goods handled. The building of the largest of the docks, No. 9, was to push the port to fourth position. The Ship Canal Co. had purchased the Manchester Racecourse for further expansion to the port, with the last race meeting held in 1901. The site was used for the construction of Dock No. 9, together with railway marshalling yards. Being an Edwardian project, postcard publishers were interested in recording the event. The first card is one of a series showing the new dock under construction. The main canal is seen with water at a higher level than that in the partially filled dock. The tall grain elevator is on the left. The other card commemorates the opening ceremony by the king and queen in 1905. A Dock No. 10 was planned but never built.

MANCHESTER SHIP CANAL.
No. 9 DOCK.

Opening Ceremony, July 13th, 1905.

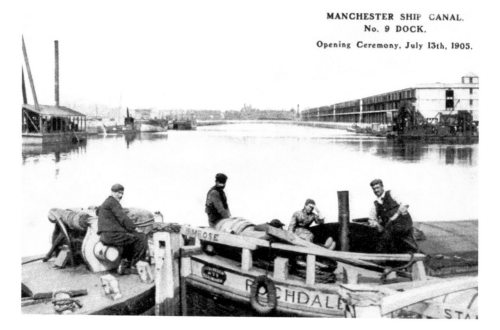

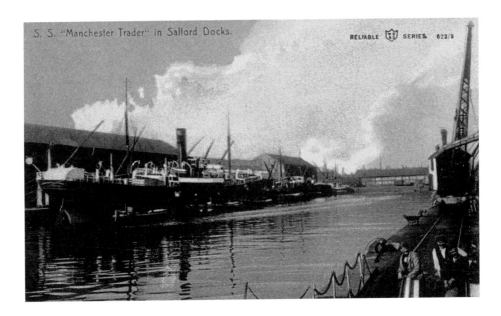

Manchester Liners

After the Ship Canal had opened in 1894 there was opposition to using the Port of Manchester by other ports and some ship owners. As a response to this, it was decided to establish a fleet of vessels based in Manchester. The group was called Manchester Liners. The first two ships were bought second hand in 1898, although later ships were built for Manchester Liners. One of this first pair of ships was renamed the SS *Manchester Trader*. The other vessel became the SS *Manchester Enterprise*. Both had been built in 1890. The *Enterprise* foundered the year after purchase, but the *Manchester Trader* served the company until 1913, when it was sold. The coloured postcard, which was sent in 1907, is titled 'S.S. "Manchester Trader" in Salford Docks', and shows the first ship of this name. The later monochrome card features a subsequent *Manchester Trader* (several vessels were given the name). This ship was built in 1941, and sent to the breakers in 1963. Manchester Liners had ceased its sailings by 1985.

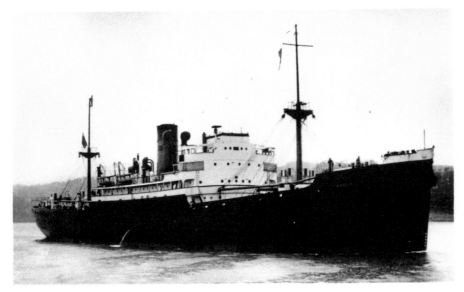

ACKNOWLEDGEMENTS

Books of this nature owe a huge debt to the photographers, artists, printers and publishers who, in times past, presented to the then public these pasteboard views of a city, its streets and buildings. A generalised acknowledgement is given here. The postcards depicted in this work are from cards in the compiler's own collection, with the exception of the football images, which were copied with grateful thanks to Paul Macnamara. Most of the other cards were obtained from postcard dealers at specialist fairs. Other people who helped with this project, by searching out Manchester cards, assisting with internet purchases, or offering general encouragement, include: Chris Breen, Ron Brown, Julia Couchman, Stephen Dignum, Xavier Goossens, John Holder, Chris Newall and Lena Ottosson. Apologies to anyone who may have been omitted. For permission to use the cards originally published by E. T. W. Dennis of Scarborough and whose rights are now held by the John Hinde Archive, thanks go to Allison Myers of Paper Island. Finally, I wish to thank Amberley Publishing for their interest in this Manchester postcard concept, and especially to editor Becky Cousins.